AMERICAN FOLK PAINTING

Selections from the Collection of Mr. and Mrs. William E. Wiltshire III

American Folk Painting

SELECTIONS FROM THE COLLECTION OF MR. AND MRS. WILLIAM E. WILTSHIRE III

An exhibition on display at The Virginia Museum, Richmond
November 29, 1977 — January 8, 1978
Organized by The Virginia Museum and Circulated by The American Federation of Arts

Catalog compiled by

RICHARD B. WOODWARD
Assistant Curator, Virginia Museum

VIRGINIA MUSEUM / RICHMOND, VIRGINIA

Cover: catalog entry 47.

First published 1977 in the United States by the Virginia Museum, Richmond, Virginia. / All rights reserved under International and Pan-American Copyright Conventions. / No part of this book may be reproduced or transmitted in any form or by any means, electronic or mechanical, including photocopy, recording, or any storage and retrieval system now known or to be invented, without permission in writing from the publishers, except by a reviewer who wishes to quote brief passages in connection with a review written for inclusion in a magazine, newspaper, or broadcast. / Printed and bound by Dai Nippon Printing Co., Ltd., Tokyo, Japan.

Designed by Raymond Geary

Library of Congress Cataloging in Publication Data

Woodward, Richard B. 1950-

 American folk painting.

 1. Painting, American—Exhibitions. 2. Painting, Modern—17th-18th centuries—United States—Exhibitions. 3. Painting, Modern—19th century—United States—Exhibitions. 4. Folk art—United States—Exhibitions. 5. Wiltshire, William E.—Art collections. I. Virginia Museum of Fine Arts, Richmond. II. American Federation of Arts. III. Title.

ND207.W66 759.13′074′013 77-24971

ISBN 0-917046-03-X
ISBN 0-917046-02-1 pbk.

Participating Museums

1977

VIRGINIA MUSEUM
Richmond, Virginia

1978

THE PHILLIPS COLLECTION
Washington, D. C.

MUSEUM OF ART, CARNEGIE INSTITUTE
Pittsburgh, Pennsylvania

THE COLUMBUS GALLERY OF FINE ARTS
Columbus, Ohio

THE DENVER ART MUSEUM
Denver, Colorado

FINE ARTS GALLERY OF SAN DIEGO
San Diego, California

1979

SEATTLE ART MUSEUM
Seattle, Washington

AMON CARTER MUSEUM OF WESTERN ART
Fort Worth, Texas

MUSEUM OF AMERICAN FOLK ART
New York, New York

Foreword

Through the years of its history, the Virginia Museum has shown serious interest in American art by the organization of major loan exhibitions, the publication of scholarly essays and catalogs, and, more recently, the expansion of its American galleries. These accomplishments are due, in great part, to the generous support of private collectors and donors, who have cherished the subject and promoted its overall educational value. Mr. and Mrs. William E. Wiltshire III are among those who continually share these interests with the Museum, and on this occasion we are fortunate in presenting their fine collection of American folk painting. The Wiltshires' knowledge of the subject, their devotion to sound scholarship, and their invaluable aid in research and direction to sources have made our role of preparing the exhibition and this catalog an easy and enjoyable endeavor. We are grateful to them for bringing their collection to public view and, in doing so, adding significant documentation and dimension to the ongoing study of American folk art.

Mary Black, curator of painting and sculpture at the New-York Historical Society, has brought her own special expertise and longtime experience in folk art to the catalog introduction, providing both scope and understanding of the milieu in which these artists emerged and worked. In addition to Mrs. Black, special thanks are extended to Richard Woodward, assistant curator at the Virginia Museum, for his careful gathering of information and preparation of the catalog entries, and to Carolyn Weekley, assistant to the director, for her many helpful suggestions in the preparation of this catalog.

Appreciation is also extended to Mary Allis, Robert Gunshanan, Colleen Heslip, Elizabeth Lyon, Jacquelyn Oak, Paul E. Rivard, John O. Sands, Christine Skeeles Schloss, Juliette Tomlinson, and Klaus Wust for their counsel and assistance in specific areas of research.

Finally, I would like to thank Wilder Green, director of the American Federation of Arts, and Jane Tai, assistant director of that organization, for their superb cooperation and supervision in circulating *American Folk Painting* among the participating museums.

R. Peter Mooz, Director

Introduction

by Mary Black

It is some fifty years since the reawakening of interest in the untutored, self-taught American country artist first began. Today, when most dealers and collectors of folk painting suspect that the great days when the best examples of this art form could be found in quantity are over, Mr. and Mrs. William E. Wiltshire III of Richmond, Virginia are proving that new enthusiasts with taste and interest can still assemble a comprehensive collection of American folk painting within a relatively short period.

As a child, William Wiltshire collected Civil War memorabilia, but when he set out for college he dispersed this collection. In 1967 he married Barbara Gottschalk, and in furnishing their first house they began to develop a fine arts library to help them in their search for fine American furniture and decorative arts.

A ceramic and pottery collection was begun by the Wiltshires, and European wares were accumulated with the encouragement and assistance of William Lautz (a life-long collector of these materials and, on retirement, a dealer and advisor to museums and private collectors). Alongside Japanese ceramics, European Renaissance cutlery, and French soft-paste porcelain, another group of stronger, rougher wares was growing. It was this collection of American pottery that opened the door to the Wiltshires' interest in American folk art. About a third of the major exhibition *Folk Pottery of the Shenandoah Valley* at the Abby Aldrich Rockefeller Folk Art Collection in Williamsburg (May 25-Oct. 4, 1975) was made up of pieces owned by the Wiltshires, and the beautiful volume of the same name (produced by Mr. Wiltshire) stands as a record of the direction that this interest took.

At first the Wiltshires collected folk paintings to decorate the walls of their home, but soon their enthusiasm grew beyond casual purchases. The more they learned about this art form, the more strongly they were attracted by its strong colors and bold designs. These works had an honesty and forthrightness that seemed to the Wiltshires to be lacking in academic paintings of the same period.

Later, a large, high-ceilinged room was set aside as a gallery, and museum lighting was installed. In this space, paintings are frequently moved to ac-

commodate new arrivals and to enable study of relationships between styles, periods, and types. Many of the stars of the Wiltshire constellation are portraits, the major production of American folk artists between 1785 and 1840. These, along with landscapes and genre scenes, effectively illustrate the heyday of the rural and town artists who worked for their peers within isolated nineteenth-century societies.

For the Wiltshires, every new acquisition fills a gap or expands the reach of their collection. Paintings in need of conservation are sent out for expert professional care, and careful records are kept of the treatment of each piece. Proper conservation is a major concern, and it is a regular practice of the Wiltshires to stabilize and restore each work in order to return it, as nearly as possible, to its original appearance. The overall quality of the collection is constantly strengthened as new examples are found, identified, and researched.

Dealers, art historians, students, museum curators, and directors aid the Wiltshires in their search. The Abby Aldrich Rockefeller Folk Art Collection in Williamsburg, Virginia is a noted and easily accessible resource. The knowledge and abilities of long-time dealer and expert Mary Allis of Southport, Connecticut provided them with inspiration as well as guidance and direction as the number of paintings grew to include the broad representation listed in this catalog.

When the work of untutored or little-taught painters was first rediscovered in the 1920s, it was appreciated and assessed in a way that was worlds apart from the reasons for its original creation. As artists, collectors, and dealers began to search in attics, barns, and junk shops of the New England and Middle Atlantic states (the areas offering up the greatest quantity of works), they associated the paintings of the professional, mostly self-taught artists that they found with then new directions in modern art. It is no accident that the first rediscoveries were made by people like Robert Laurent, Elie Nadelman, Charles Sheeler, William and Marguerite Zorach,

and Bernard Karfiol, who were themselves creating works akin to folk art in directness, vigor, strength, and realism. Thus, twentieth-century artists became collectors of nineteenth-century folk art, and they in turn interested other collectors of modern works in old paintings and carvings, which were born again to new use and life.

Abby Aldrich Rockefeller, who in 1929 was one of the founders of the Museum of Modern Art as well as a supporter of contemporary artists, also became an avid collector of folk art. Her collection is today the largest and most comprehensive museum collection of American folk art, having been enriched and enlarged through the years by acquisitions in the spirit and categories of her interest. Located in its own building in Williamsburg (the first especially designed as a sympathetic background for such materials), it is readily available for study and comparison with the Wiltshires' own acquisitions.

Today, most major museums, historical societies, and restoration villages have representations of American folk art in varying degrees; private collectors, with equal enthusiasm, have assembled collections both large and small. During the period of the Wiltshires' interest in this subject, particularly, great advances have been made in assessing and describing the output of many folk painters. Mr. Wiltshire himself has taken part in this fascinating search and appraisal. "The real challenge," he writes, "is discovering new artists and recording information about them. Finding works which are unrecorded and untouched is a real adventure." In this collection, the Payne Limner is just such a discovery. Today, like others involved in the search for American folk art, he feels that the renaissance of interest in this art form is a phenomenon that is here to stay.

Museum professionals were among the first to observe the relationship between folk art and the heightened realism being practiced by contemporary artists. In 1924, Juliana Force, director of the Whitney Studio Club, sponsored a landmark exhibition of folk art in New York at the Club's Eighth Street location. Holger Cahill, national director of the Index of American Design, began the great record of existing examples of early arts and skills in 1935. This collection of precise watercolor renderings, by artists

working for Cahill under the sponsorship of the Works Progress Administration, forms an unparalleled archive of American folk and decorative arts. It was also Cahill who organized exhibitions of folk painting and sculpture at the Newark Museum and the Museum of Modern Art in the 1930s. In 1932, his *Art of the Common Man* at the Museum of Modern Art successfully established the link between folk art of the eighteenth and nineteenth centuries and the modern art that was being shown at the new museum.

In addition, among the supporters and suppliers of early collections of folk art were dealers in modern art. Edith Halpert, married to American painter Sam Halpert, sought out and found many of the works in Mrs. Rockefeller's early collection. Since the mid twenties, many other collections of folk art have been formed. Among the largest of the private collections are those of Electra Havermeyer Webb (now at the Shelburne Museum), Jean and Howard Lipman (most of the early part of that collection is now at the New York State Historical Association at Cooperstown), Colonel Edgar William and Bernice Chrysler Garbisch, Nina Fletcher Little, Herbert W. Hemphill, Jr., Stewart Gregory, Bernard Barenholtz, and Peter Tillou.

Looking back to the years when these strong, naive works were first brought back to hang in houses and, eventually, in museums (during the period of the creation of folk art, its exhibition in an art museum was unknown), one becomes aware once more of the remarkable difference between the way it was then seen and its original intent. Today, in museums devoted to folk art, such as the Abby Aldrich Rockefeller Folk Art Collection, the New York Historical Association in Cooperstown, and the Museum of American Folk Art in New York; in restorations like the Shelburne Museum, Old Sturbridge Village, Deerfield, and Greenfield Village; and at leading art museums and noted historical societies, ongoing research is expanding the view of what really took place in the great surge of creative effort that occurred between the eve of the Revolution and the common use of the camera.

Between 1640 and 1840, scores of painters attempted to fill the needs of their contemporaries and peers in rural and suburban America in recording the appearance of varied and culturally-isolated segments of society. Portraiture was the preeminent need, but eventually they also produced interiors, exteriors, farm scenes, landscapes, still lifes, and religious and genre scenes. By the time the Revolution ended and the slow, painful, and exhilarating task of building a new nation of united and independent states began, a tradition of native art by self-taught practitioners was already well established.

Between 1700 and 1750, a well-defined school of portrait and religious painting by more than a score of painters existed along the Hudson River, from New York to Albany. Earlier folk painters had worked in New England, and one of the New York artists appears to have ventured as far south as Williamsburg and Jamestown, Virginia, with a way stop in Newport, Rhode Island. In South Carolina, Maryland, New Jersey, and Virginia, isolated examples of folk art were being created.

On the eve of the Revolution, a group of Connecticut painters entered into the prolific production of portraits and a few landscapes, shifting the center of folk art activity from New York to southern New England. As the new states emerged, a new and independent middle class, devoted to the rights and individual worth of each of its members, arose. Every man might attain privileges and position formerly available only to the rich and well-educated. In this milieu, in which each person was considered an integral part of his immediate society, an expanding record of the appearance of the rising middle class was begun. In small towns, far removed from large urban centers, country artists set to work.

Separately, they found solutions to problems of perspective, anatomical representation, and accurate portrayal. Occasionally, this development took the form of a cooperative venture, through observation or knowledge of other artists' work. This process was aided by the natural talents of the artists, and was intensified by endless repetition of the lessons learned. The results were varied, but the folk artists acclaimed today—those identified as well as those known only by style—were also the ones most frequently patronized in

their own times. Originally, these paintings were practical and often beautiful records of faces, farms, and events. Today, they are treasured not only for their value in presenting a portrait of colonial America and the early republic, but also for their enduring aesthetic traits.

As these works came into respectability in this century, the anonymity of many of the artists led to a curious and romantic fiction. The folk artist was viewed as a failed itinerant, a dreamer inadequate to business or trade who took up painting because he was unsuccessful at everything else. He was seen as idly wandering through the countryside, painting for board and room—the snake-oil charlatan of early America. Occasionally a painter fulfills this tradition. The nearest realities to the legend are the almshouse painters of Pennsylvania, all German immigrants, all part-time residents, "via the alcohol route," at one or more of the Pennsylvania almshouses, which were their favored subject. Yet even here the record is far from the whole story. The organization and skill with which these late nineteenth-century practitioners used their talents suggest that they had early successes as lithographers and painters before intemperance took over their lives. In the Wiltshires' collection, one of John Rasmussen's works is a fine and unusual example of the genre (catalog entry 50).

As folk paintings reached never-before achieved positions of honor on museum walls, curators, collectors, dealers, and art and social historians began to attempt to identify the makers of correlated groups of paintings. As a result, in the last two decades the professional folk painter has been returned to an active, productive, and honored place within his society. Although repetition was the artist's accepted mode of development, the former concept of the folk painter as a hack artist has been dispelled as his history has unfolded.

An older legend, known as "the headless body theory," still lives, although the evidence against it is strong. Its persistence is fortified by two practices that took place immediately before and immediately after the heyday of the American folk artist. One was the use of the velvety mezzotint as the source for background, costume, and pose in pre-Revolutionary portraits. The other, beginning at mid-nineteenth century, was the common practice among early photographers in using painted backgrounds and stage furniture as settings. Since poses in folk portraits often are identical, backgrounds similar, and costumes occasionally the same, the fiction arose that in off seasons the folk painter would paint figures fat and lean, young and old, then in good weather travel with these "headless bodies," finally adding the only original notes: faces to match those of the clientele he solicited along the way. It is a grand and funny tale perpetuated in fiction and in earnest belief, but so far lacking in documentary proof.

What *is* known is this. There is no record of these practices in the many letters, account books, diaries and journals of folk painters now known. Costumes did indeed move within a family unit. For instance, sisters and sisters-in-law are known to have worn the same dresses, collars, jewelry, and combs as they sat for their portraits. Two particular painters, Jacob Maentel and Ammi Phillips, may have carried with them distinctive green umbrellas that appear in full-length portraits by them. In a Boston Museum acquisition, clothing, jewelry, and family furniture went along with a group portrait by Erastus Salisbury Field of the Moore family of Ware, Massachusetts, totally precluding the possibility of advance preparation. Ammi Phillips did several copies of one subject, changing the numbers of embroidered hearts on the sitter's muslin collar to individualize the copies intended for three of four children of the subject (surely a fourth likeness once existed).

Often, the reality that we know today is so much better than the invention, and once a folk painter's life is revealed, interested observers look for more examples of his work and further biographical information. Where many unknowns once stood, now stand Pieter Vander Lyn, Gerardus Duyckinck, John Durand, Winthrop Chandler, Reuben Moulthrop, Rufus Hathaway, Simon Fitch, John Brewster, Jr., Ammi Phillips, Erastus Salisbury Field, Joseph Stock, Edward Hicks, Charles Hofmann, John Rasmussen, and Jacob Maentel, all with records of busy and active lives and listings of known works numbering in the fifties and hundreds. Many more are identified, while some few are still called after the names of the families they painted. One of these, the Payne Limner, emerges in this exhibition, represented by three of ten known

Payne family portraits (catalog entries 4, 5, and 6). All are Virginia subjects, and the style is reminiscent of, but seemingly different from, that of John Durand, who was working in Virginia from 1770 to about 1782.

The Wiltshire collection provides insight into the working methods and styles of other artists, as seen in the 1793 Rufus Hathaway portraits of two members of the Sampson family of Duxbury, Massachusetts (catalog entries 7 and 8). The portrait of Captain Sylvanus Sampson was painted less than four months after that of his wife and cost the same, yet it seems far less practiced and sure than the dazzling and typical Hathaway style evident in the wife's portrait. Hathaway himself is a good example of the artist working within and for a society of his peers. He began his career as a painter in Taunton, but soon settled in nearby Duxbury, where he lived and worked, not only as a painter but also as a practicing physician, for thirty years until his death in 1822.

The Child of the Hubbell Family by Jonathan Budington, Ralph Earl's portraits of John and Mary Hill Nichols, and *Major Andrew Billings* by the Beardsley Limner (catalog entries 2, 9, 10, and 11) represent the emergence of the second well-defined school of artists, the painters of a large and related body of work in Connecticut between 1770 and 1805. The portrait of the Reverend Ebenezer Gay, Sr. is by Winthrop Chandler, who was the first to rise among these Connecticut folk artists (catalog entry 1). Echoes of style and overlapping territories indicate acquaintance with each other's production; some members of this group of country painters are known actually to have studied each other's work, as in the case of Simon Fitch, who was briefly an apprentice of Winthrop Chandler.

Out of this late eighteenth-century Connecticut school other painters developed. Isaac Sheffield was one of them, and the full-length portrait of Mary Ann Wheeler is a fine example of his style (catalog entry 33).

The two Ammi Phillips portraits of about 1824 show the same general transition, but as it developed within one prolific artist's work over a long period (catalog entries 23 and 24). This pair, known in the early 1940s, disappeared from sight in about 1950; they are now restored to view in the Wiltshire collection.

Woman with Shawl and Cap and *Man with Large Bible* bridge the period between Phillips' border period (1811-1818) and his Kent period (1830-1838). Of all the folk portraits now known, those by Phillips are among the best and the most inventive. His contemporary, the artist John Vanderlyn, had this to say of Phillips' career and position in his society:

> Indeed moving about through the country as Phillips did and probably still does, must be an agreeable way of passing ones time. . . . Were I to begin life again I should not hesitate to follow this plan, that is, to paint portraits cheap and slight . . . it would besides be the means of introducing a young man to the best Society and . . . might be the means of establishing himself advantageously in the world. . . .*

The portrait of two children attributed to Joseph Stock was found in southeastern New York State (catalog entry 43). Unlike most folk painters, Stock kept an account of his work. His journal, written between 1832 and 1846, records 912 paintings. Approximately seventy works of this period have been identified, while a dozen more have been identified in the past year (by this writer) as the work of three years in Orange County, New York (between 1852 and 1855); there, early in his stay, he advertised completion of a hundred portraits of county residents. Thus, portraits by Joseph Stock have become one of the newest treasures to seek in the folk art field. The Wiltshire painting follows in the tradition of other Stock portraits in the handling of the full-length figures depicted on a reverse-patterned Scotch grain carpet; the children are presented as though on a stage surrounded by billowing folds of curtains.

An investigation of the work of folk artist Noah North is presently under way. The posthumous portrait of young Dewit Clinton Fargo, signed and dated by North, extends the range of New York works known to be by this painter, whose sense of design and style was exceptional (catalog entry 32).

Another New York painting, the bold and powerful full-length portrait of Mary E. Kingman, signed and dated by Susan C. Waters, establishes the style of this artist (catalog entry 40). Yet another portrait, the dramatic likenesses of Mr. and Mrs. David Crane of Illinois, painted by Sheldon Peck in the mid 1840s, is a discovery that increases knowledge of this artist's

production (catalog entry 41). The trompe l'oeil frame, complete with wood grain, is a unique characteristic of Peck.

Such portrait subjects, prospering citizens in rural areas, were viewed by their recorders as equals. Indeed, all the artists' account books, receipts, journals, and descriptions indicate that their travels to find subjects most often took them to places where friends, relations, or acquaintances would sit for portraits and permit the artist to use the results to introduce themselves in unfamiliar territory.

In addition, the Wiltshire collection contains a large number of landscapes and genre scenes which further illustrate the appearance of prospering farms and the increasing ease of transportation. Thus the German immigrant and sometime resident of the Berks County Almshouse, John Rasmussen, records one of the well-kept farms of that Pennsylvania county, and Henry Dousa shows the immaculate Indiana house and farm of H. Windle (catalog entries 50 and 49). L. Johnston in Connecticut delineates a southern New England scene, while ship portraitist James Bard records the *King Bird* (catalog entries 34 and 46). The riches of the harvest are described almost surrealistically in Newark artist Isaac W. Nuttman's *Still Life,* its elegance contrasting with the naive and colorful description offered by Susanna Sibbel's Pennsylvania watercolors of bees and birds, stone house and bridge, village, and livestock (catalog entries 16 and 47).

Thus the Wiltshire collection, spanning one hundred years of American folk painting, is a fine selection of portraits, landscapes, and genre scenes which illustrates the heyday of the professional, self-taught painter. The eighteenth-century portraits are especially rich, while outstanding examples of portraits and landscapes by identified folk painters of the first half of the nineteenth century round out this recently formed collection. The representation of southern folk art is a further strength that expands its geographical reach. In bringing this important assembly of newly discovered works by American folk painters to a wide audience, the Wiltshires are extending knowledge and appreciation of this evocative and beautiful aspect of American art.

*Vanderlyn to John Vanderlyn, Jr. (nephew), Sept. 9, 1825, Kingston Senate House Museum, Kingston, N. Y.

A Note on Related Research

Continuing research in American folk art has provided in recent years a number of important articles, publications, and exhibitions related to artists represented in the Wiltshire collection. These include: Christine Skeeles Schloss, *The Beardsley Limner and Some Contemporaries,* The Colonial Williamsburg Foundation, 1972; Klaus Wust, *Virginia Fraktur: Penmanship as Folk Art,* Shenandoah History, 1972; Frederick S. Weiser, *Fraktur: Pennsylvania German Folk Art,* Science Press, 1973; Gail and Norbert H. Savage and Esther Sparks, *Three New England Watercolor Painters,* The Art Institute of Chicago, 1974; Klaus Wust, "Fraktur and the Virginia Germans," *Arts in Virginia,* Virginia Museum, Fall 1974; Robert C. H. Bishop, *The Borden Limner and His Contemporaries,* The University of Michigan Museum of Art, 1975; Marianne E. Balazs, "Sheldon Peck," *Antiques,* August 1975; *The Paintings and the Journal of Joseph Whiting Stock,* edited by Juliette Tomlinson, Wesleyan University Press, 1976; Elizabeth R. Mankin, "Zedekiah Belknap," *Antiques,* November 1976.

Jacquelyn Oak of the Museum of Our National Heritage and Nancy Mullen of the Shelburne Museum are preparing their collaborative research on Noah North for a major exhibition and catalog. The work of Susan Waters and the Payne Limner are subjects of masters theses by Colleen Heslip of the Cooperstown Program and Elizabeth Lyon of Virginia Commonwealth University, respectively. The Henry Francis du Pont Winterthur Museum is organizing an exhibition of the work of Jacob Maentel.

Catalog

Catalog entries are arranged chronologically. Measurements are in inches, followed by centimeters; height precedes width.

When a work is signed or dated, it is stated on the final line of the catalog heading.

References indicate sources in which a specific painting has been discussed or mentioned.

Notes referring to the catalog footnotes are found on page 107; an index to artists is on page 108.

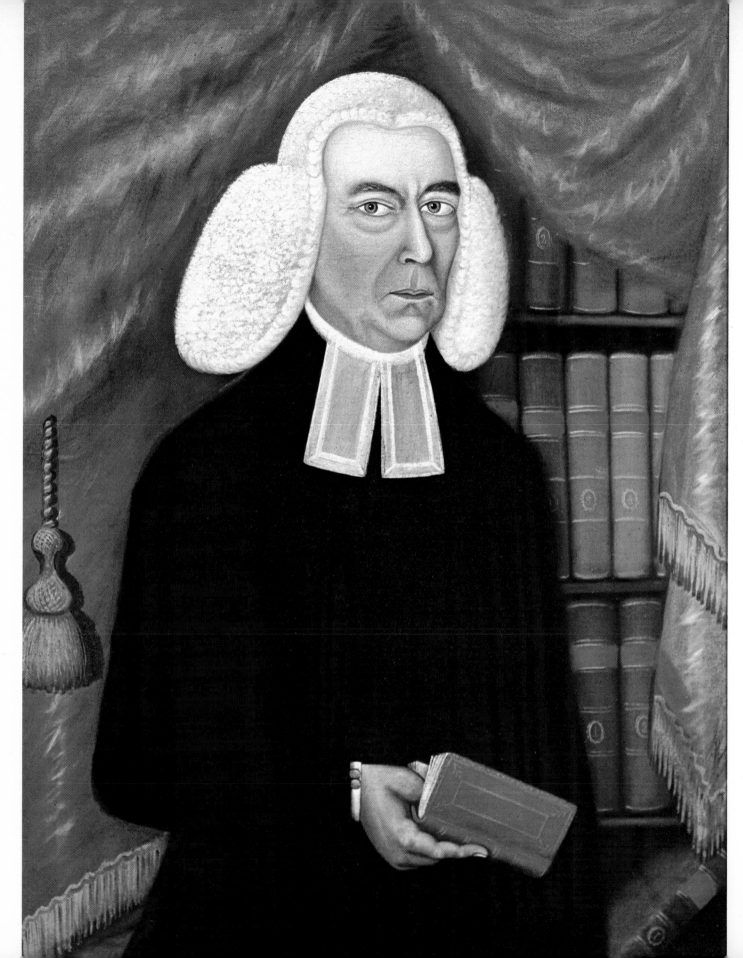

1.

1.

WINTHROP CHANDLER (1747-1790)
Rev. Ebenezer Gay, Sr.
1773, Suffield, Connecticut
Oil on canvas, 38 by 29 (96.5 by 73.6)

The Reverend Ebenezer Gay, Sr. (1718-1796) was descended from a distinguished New England family that settled in Massachusetts early in the seventeenth century. A graduate of Harvard in 1737, Gay entered theological studies and in 1742 was ordained in Suffield, Connecticut, where he was minister of the Congregational Church until his death. Gay married Mrs. Hannah Angier in 1742, and she died in 1762. He married Mary Cotton Cushing of Scituate, Massachusetts in 1763, and they had five children.[1]

Many details of Gay's life are revealed in the diary he kept daily for more than forty years. The diary also records a surprising amount of travel in upper-class circles; for instance, two entries mention the presence of "J. Adams" and "Col. Washington" (George Washington?) in the Gay home on October 13, 1767 and February 2, 1768, respectively. The diary also mentions another person, simply called "Mr. Chandler," as having visited Gay's home nine times between May and August of 1773.[2] In all likelihood this is a reference to the painter Winthrop Chandler, who had come in order to paint the portrait of Gay.

Chandler lived all but the last five years of his life in Woodstock, Connecticut and although he was listed as a fancy and house painter, he is primarily known today for some fifty surviving portraits of relatives and friends from nearby towns. His life was marred by financial difficulty, and it is thought that some of the portraits were done to satisfy debts to relatives. He was married and was the father of seven children.[3]

Although it is thought that Chandler did not travel extensively, there is no reason to doubt that he covered the thirty-five or forty miles from Woodstock to Suffield to paint this portrait, possibly also searching for other commissions at the same time. The close stylistic similarities between this portrait and other works by Chandler, and the concentration of visits to Ebenezer Gay's home offer convincing support to an attribution to Winthrop Chandler in 1773. Like Chandler's other portraits, the portrait of Gay is a work of expressive strength in which the costume and surroundings describe the profession and intellectual interests of the sitter. Although the forms are naively rendered, Reverend Gay's character was perceived in anything but a naive manner.

Provenance:
Descended in the Gay family.
Tillou Gallery, Litchfield, Connecticut.

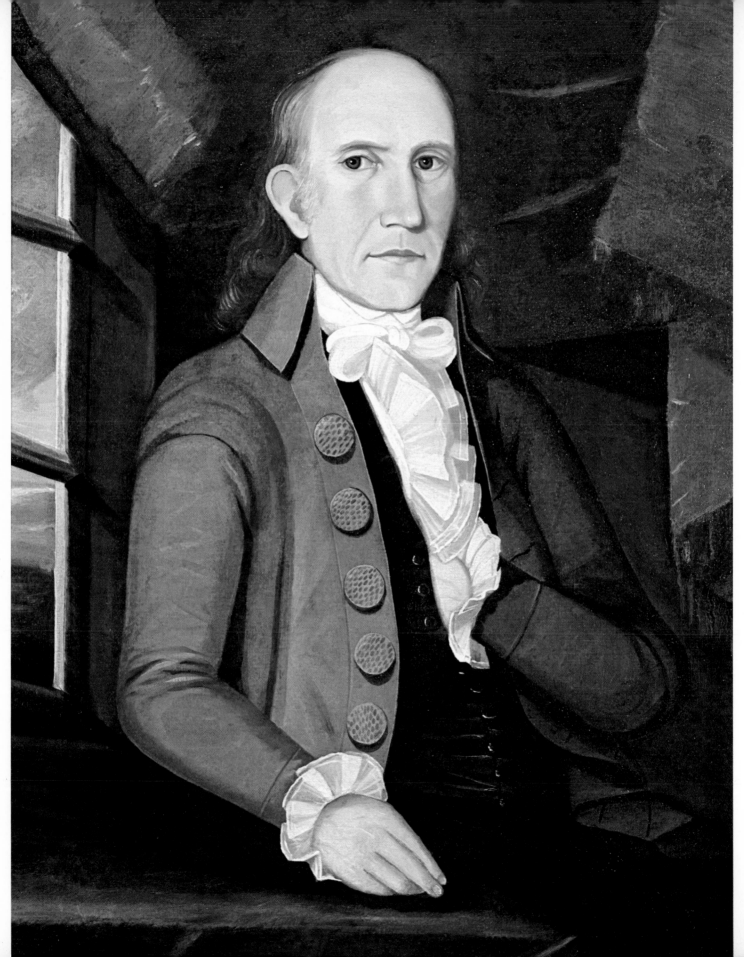

2.

2.

THE BEARDSLEY LIMNER
Major Andrew Billings
ca. 1785, New England
Oil on canvas, 30 by 25 (76.2 by 63.5)

After having been stored and forgotten on a farm in New York State, this portrait came to light again only three years ago. A label on the back identifies the sitter as: "Major Andrew Billings/born 1743 died 1808/son of John Billings & Elizabeth Cage/fought in Revolution on Staff of/Gen. Washington." Major Billings was a jeweler and watchmaker in Poughkeepsie, New York. He was married to Cornelia Livingston. In 1799, he served as a trustee of Poughkeepsie.[4]

Based on stylistic evidence, this portrait is attributed to the Beardsley Limner, a portrait painter active in New England between 1785 and 1805. Because he failed to sign his works, this anonymous artist has been named after his paintings of Hezekiah and Elizabeth Beardsley, which are in the Yale University Art Gallery. His portraits are characterized by stiff, tightly-drawn figures seated in standard poses and set in a shallow space.

The Beardsley Limner applied a fairly uniform set of formulas to his portraits; for example, Billings' hand, with the fingers closely drawn together, is strikingly similar to the hand of Elizabeth Beardsley, circa 1785, at Yale, and that of James Steel, circa 1790, in the Abby Aldrich Rockefeller Folk Art Collection, Williamsburg, Virginia. The slight turn of Billings' head, revealing the profile of one cheek, and the large almond-shaped eyes and tightly-pursed lips are also hallmarks of the Beardsley Limner's style, as are the prominent buttons and the awkward space in which Billings is seated.[5]

Fourteen other portraits by this artist are known today, and the homes of the sitters indicate that he worked in Massachusetts and Connecticut along the Boston Post Road. It is not known where the Billings portrait was painted, but if it was done in Poughkeepsie, this would be a previously unknown area for the Beardsley Limner.

Provenance:
Maze Pottinger Antiques, Bloomfield Hills, Michigan.

3.

ARTIST UNIDENTIFIED
Taufschein for Elizabetta Ernlin
1787, Pennsylvania
Watercolor on paper, 7⅞ by 12⅝ (19.7 by 32.1)
Dated at left: *1·7·8·7*

German immigrants to the New World settled most densely in Pennsylvania in closely knit communities where the art and customs brought from their native lands flourished in the years between the mid 1700s and 1800s. One of their popular art forms, known today as "fraktur," combined script and decorative motifs painted in watercolor on paper. The term fraktur (from the Latin *fraktura,* i.e. a fracture) has been applied to this art form because of the commonly used German script which, indeed, does have a fractured appearance when compared to the smoother Roman cursive script.[6]

Fraktur artists produced a number of different types of works, but they were most often commissioned to create letters of birth and baptism, called *Taufschein* in the German.[7] Imaginative combinations of birds, hearts, flowers, stars, and other decorative motifs were joined with script to make these "documents" both colorful and fascinating.

This particular *Taufschein,* noteworthy for its early date and for the quality of the script, records the birth and baptism of Elizabetta Ernlin in 1776, and it names Johannes Miller and his wife as her godparents. A special charm is imparted by the motif of the two stylized birds, representing pelicans, beneath the heart. In an act that Christians have adopted as a symbol of Christ's shedding of blood for Man, the pelicans peck their breasts to feed their young with their own blood.

A general interpretation of the term "folk art" encompasses the painting, sculpture, and decorative creations of individuals who lacked thorough formal or academic training. A stricter interpretation, however, defines folk art as "a traditional, often ethnic expression which is not affected by the stylistic trends of academic art."[8] The latter definition suggests a connotation associated with European folk cultures, and it is in this sense that the fraktur creations of German-American communities are among the most representative work of American folk art.

Provenance:
Edgar William and Bernice Chrysler Garbisch.

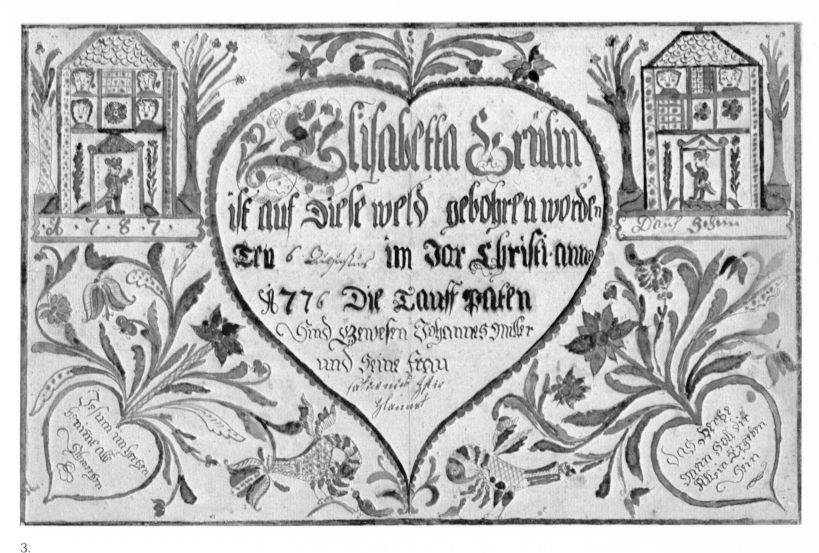

3.

4.

THE PAYNE LIMNER
Martha Payne
ca. 1791, Goochland County, Virginia
Oil on canvas, 43⅞ by 37¾ (111.5 by 95.9)

Martha Payne, born in 1773, was the second child of Archer and Martha Dandridge Payne of Goochland County, Virginia. She was an elder sister of Archer Payne, Jr. and Jane Payne (catalog entries 5 and 6). In 1796 Martha married Jeremiah Strother, and she bore two children. Although the date of her death is uncertain, it is known that her husband did remarry.[9]

The Archer Payne family was descended from several distinguished Virginia families. Archer Payne, born in 1748, was the son of Colonel John Payne, the owner of "White Hall," who represented Goochland County in the House of Burgesses from 1752 until 1768. In 1769 Archer married Martha Dandridge, daughter of Nathaniel West Dandridge and Dorothea Spotswood Dandridge, who in turn was the daughter of Colonel Alexander Spotswood, Governor of Virginia under the British Crown-appointed governor, from 1710 to 1722. Archer and Martha Dandridge Payne were the parents of eight children; she died in 1791.

This portrait is one of ten paintings of members of the Archer Payne family. All ten date from about 1791 and are attributable to the same artist who, for want of a signature or other identification, is called the Payne Limner. Information regarding this artist is scarce, but the Payne family considered him a talented painter, when he was sober.[10] With the exception of the mother and the eldest daughter, Annie, who are represented indoors, all the subjects are pictured out-of-doors, presumably on the grounds of "New Market," Archer Payne's plantation-estate in Goochland County, Virginia.

In her portrait, Martha wears a simple string necklace and she holds a peach and a fan. The fan appears in portraits of other ladies in the Payne family by the Payne Limner. Although little is known about this artist, his paintings of the Payne family members show him to have been a very able portraitist who had a special talent for conveying a pleasing sense of warmth and naturalness.

Provenance:
Descended in the Payne family.

Exhibited:
Roanoke Fine Arts Center, Roanoke, Virginia, *A Virginia Sampler,* March 14 to April 24, 1976.

5.

THE PAYNE LIMNER
Jane Payne
ca. 1791, Goochland County, Virginia
Oil on canvas, 41¾ by 35⅝ (106.1 by 90.5)

Jane Payne, born in 1778 or 1779, was the fith child of Archer and Martha Dandridge Payne and younger sister of Martha and Archer, Jr. (catalog entries 4 and 6). She was married first to Robert Bolling, son of John and Mary Jefferson Bolling of "Chestnut Grove" in Chesterfield County, Virginia. Their marriage was childless, and family records note that Jane was remarried in 1805, this time to James B. Ferguson. She gave birth to a daughter, but she died in 1806 while only in her late twenties.[11]

In the portrait, Jane holds a sprig of wild strawberries, and a filled basket is set nearby. As in the portraits of Martha and Archer, Jr., the Payne Limner has painted a setting of tree trunks, foliage, and atmospheric sky, and has endowed it with a certain warmth by the use of earth tones and spontaneous brushwork.

Provenance:
Descended in the Payne family.

Exhibited:
University of Virginia Art Museum, Charlottesville, Virginia, *Bicentennial Exhibition: Art in the Age of Jefferson,* March 14 to April 23, 1976.

6.

THE PAYNE LIMNER
Archer Payne, Jr.
ca. 1791, Goochland County, Virginia
Oil on canvas, 41⅞ by 35¾ (106.4 by 90.8)

Archer Payne, Jr., born in 1775, was the third child and first son of Archer and Martha Dandridge Payne. Little is known about Archer, Jr., except that he died unmarried.[12] The date of his death is not known. The Payne Limner represented him as a gentlemanly and successful hunter, as witnessed by the rifle and dog, as well as the squirrel that lies in the lower left corner.

Provenance:
Descended in the Payne family.

Exhibited:
University of Virginia Art Museum, Charlottesville, Virginia, *Bicentennial Exhibition: Art in the Age of Jefferson,* March 14 to April 23, 1976.

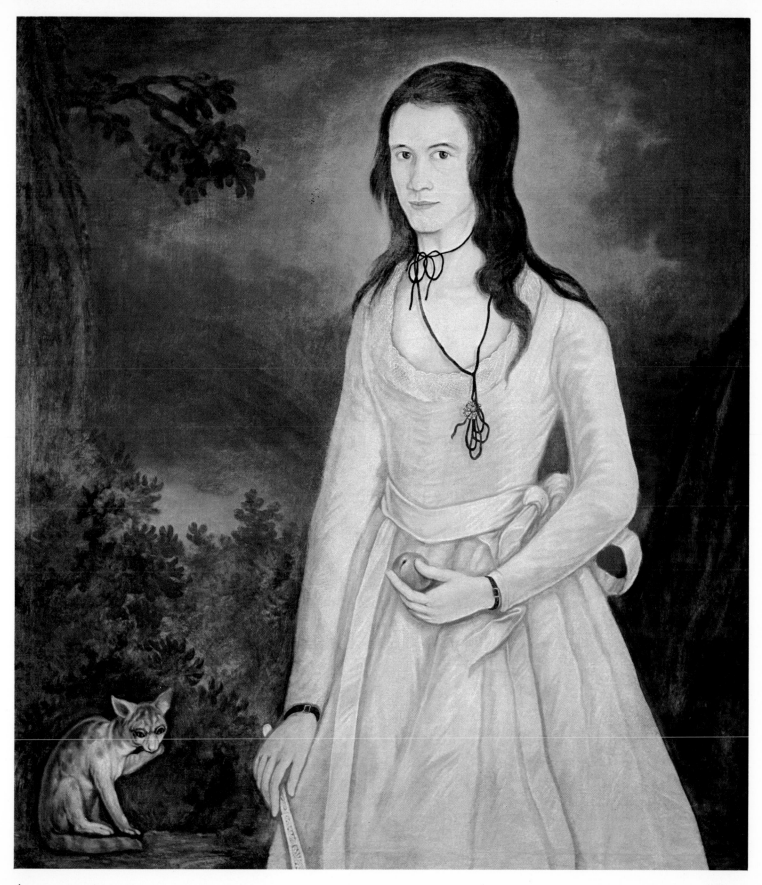

4.

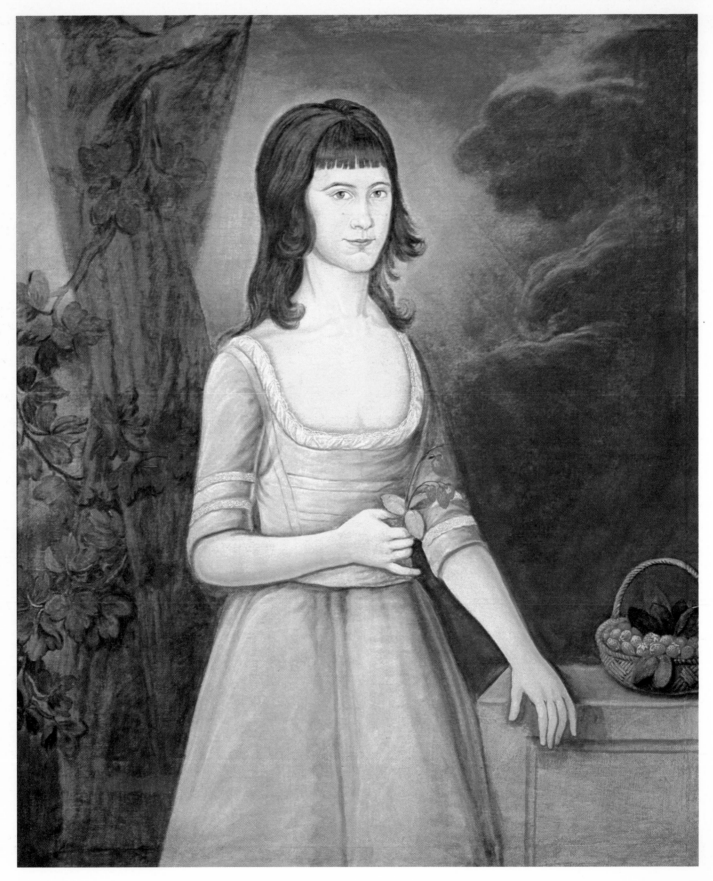

5.

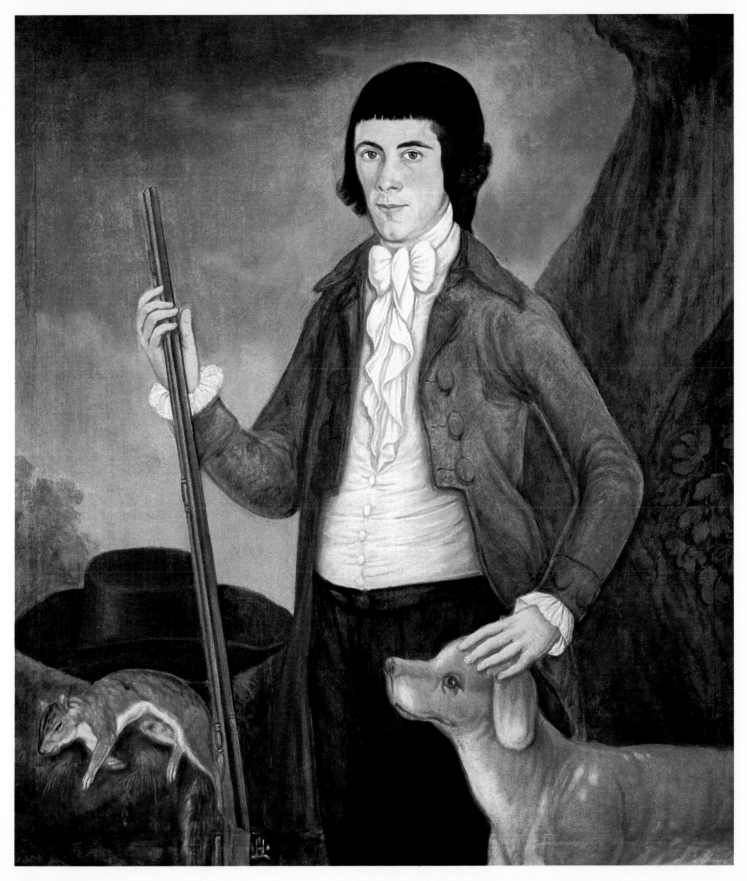

6.

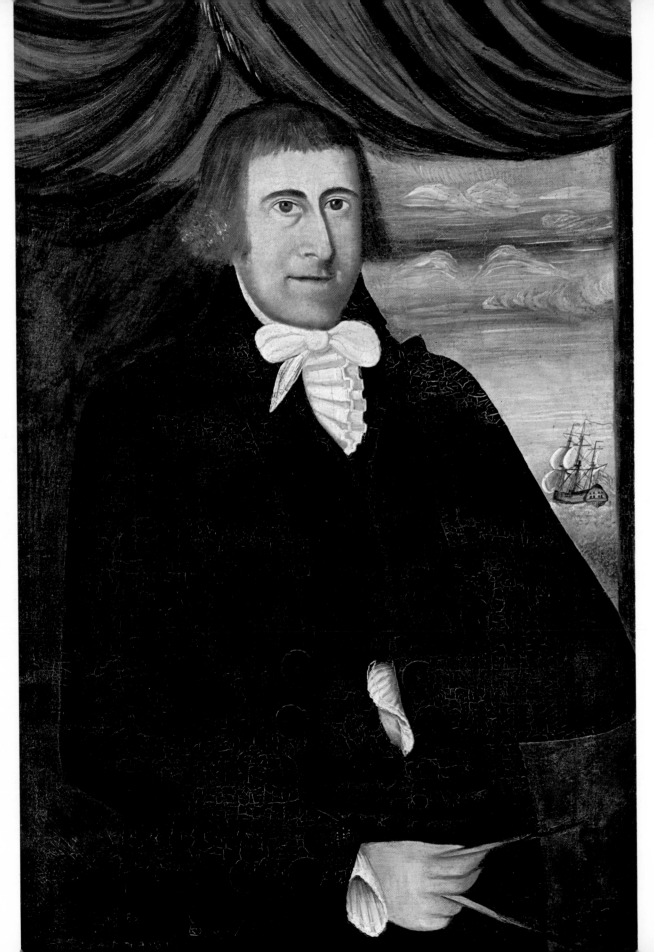

7.

7.

DR. RUFUS HATHAWAY (1770-1822)
Capt. Sylvanus Sampson
1793, Duxbury, Massachusetts
Oil on canvas, 37 by 25 (94 by 63.5)

Captain Sylvanus Sampson (1761-1848), wealthy shipping merchant and resident of Duxbury, Massachusetts, was a descendant of one of Duxbury's first citizens, Henry Sampson, who settled there in 1620. In 1787, Captain Sampson married Sylvia Church Weston. At Sampson's death in 1848, his estate totaled over $13,000, and his holdings included a farm, salt works, wharf, stores, and at least seven ships.[13]

From the original bill of sale, we learn that this portrait of Captain Sampson was painted by Rufus Hathaway and was paid for in 1793:[14]

Duxbury April 29—1793

Dr
Capt Sylvanus Sampson to Rufus Hathaway
to painting one portrait	£ 1	10	0
inerframe & cloth		4	
gilding the frame		3	4

£ 1 = 17 = 4

Received payment

Rufus Hathaway

A label on the back of the painting also names Captain Sampson as the subject and identifies Hathaway as the artist.

An itinerant painter, Hathaway had moved to Duxbury in the early 1790s, probably from Freetown, Massachusetts. He quickly took to doing portraits of prominent residents of Duxbury, but when he married Judith Winsor in 1795 his father-in-law persuaded him that his economic security would be increased if he became a doctor. After studying with Dr. Isaac Winslow, Hathaway opened a medical practice in Duxbury which he conducted for twenty-seven years. In 1822, the year of his death, he was named an honorary fellow of the Massachusetts Medical Society. During his years as a doctor he continued to paint, though at a reduced rate. In all, about twenty works, mostly portraits and miniatures, are known today.[15]

Although Hathaway's paintings are marked by a certain naive awkwardness, they do not lack bold design. The figure of Captain Sampson fills the picture surface to its edges. This endows the portrait with a striking, almost monumental appearance. To identify his profession as a sea captain, Captain Sampson holds calipers, and a ship under full sail is pictured in the background.

Provenance:
George Marcus Winslow.
Graham T. Winslow.
Richard K. Winslow.
Vose Galleries, Boston.

Exhibited:
"King Caesar" House, Duxbury, Massachusetts, until 1974.

Reference:
Little, Nina Fletcher. "Doctor Rufus Hathaway." *Art in America* 41 (Summer 1953):95-139.

8.

DR. RUFUS HATHAWAY
Sylvia Church Weston Sampson
1793, Duxbury, Massachusetts
Oil on canvas, 37½ by 25¼ (95.3 by 64.1)

Sylvia Church Weston Sampson, who married Capt. Sylvanus Sampson (catalog entry 7) in 1787, was the daughter of Ezra "King Caesar" Weston, a famous merchant of Duxbury, Massachusetts. "King Caesar" and his son Ezra, Jr. were listed in Lloyds of London as the largest shipowners in America, and their fleet boasted more than 100 ships. Thus, the marriage certainly made this a prodigious mercantile family. Mrs. Sampson died of the measles in 1836.[16]

As was frequently the custom, an artist would be commissioned to paint portraits of all the members of a family, and the Westons, like their Duxbury neighbors the Winsors, engaged the services of Rufus Hathaway for this purpose. Altogether, Hathaway painted eight Weston-Sampson likenesses. Captain Sampson paid for his own portrait, but a different bill of sale shows that Ezra Weston paid for his daughter's portrait.[17] Hathaway's six portraits of the adult members of the Weston family are all matched in size.

Simple and bold in design, the portraits of Captain and Mrs. Sampson are companion pieces; when hung with Mrs. Sampson to the Captain's left, the subjects face each other and are united in design by the strong diagonals of their inclined arms. The only note of luxury in this otherwise austere portrait is the enameled scent bottle that Mrs. Sampson holds in her left hand. Unfortunately, Hathaway was not a masterful technician, for many of his paintings, including these, have sustained extensive surface crackling.

Provenance:

George Marcus Winslow.
Graham T. Winslow.
Richard K. Winslow.
Vose Galleries, Boston.

Exhibited:

The Pilgrim Hall and The Plymouth Antiquarian Society, Plymouth, Massachusetts, *Remember the Ladies: Women in America 1750-1815,* June 29 to September 26, 1976; The High Museum of Art, Atlanta, Georgia, October 16 to November 14, 1976; The Corcoran Gallery of Art, Washington, D.C., December 3 to December 31, 1976; The Chicago Historical Society, Chicago, Illinois, January 17 to February 20, 1977; The Lyndon Baines Johnson Memorial Library, Austin, Texas, March 15 to April 23, 1977; The New-York Historical Society, New York City, May 10 to June 15, 1977.

"King Caesar" House, Duxbury, Massachusetts, until 1974.

References:

DePauw, Linda Grand and Conover Hunt. *Remember the Ladies: Women in America 1750-1815.* New York: Viking Press, 1976.

Little, Nina Fletcher. "Doctor Rufus Hathaway." *Art in America* 41 (Summer 1953):95-139.

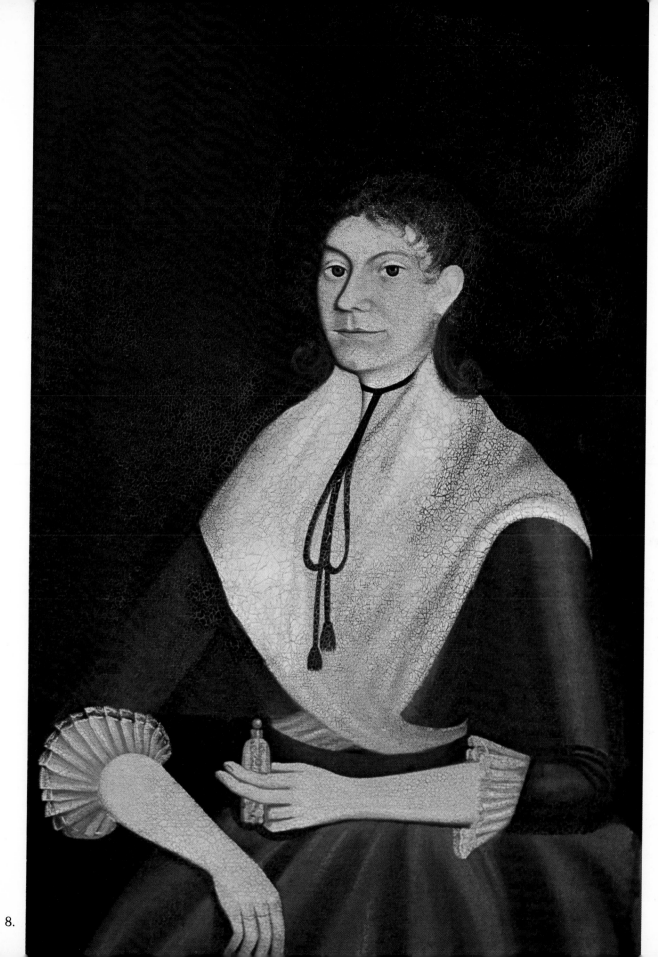

8.

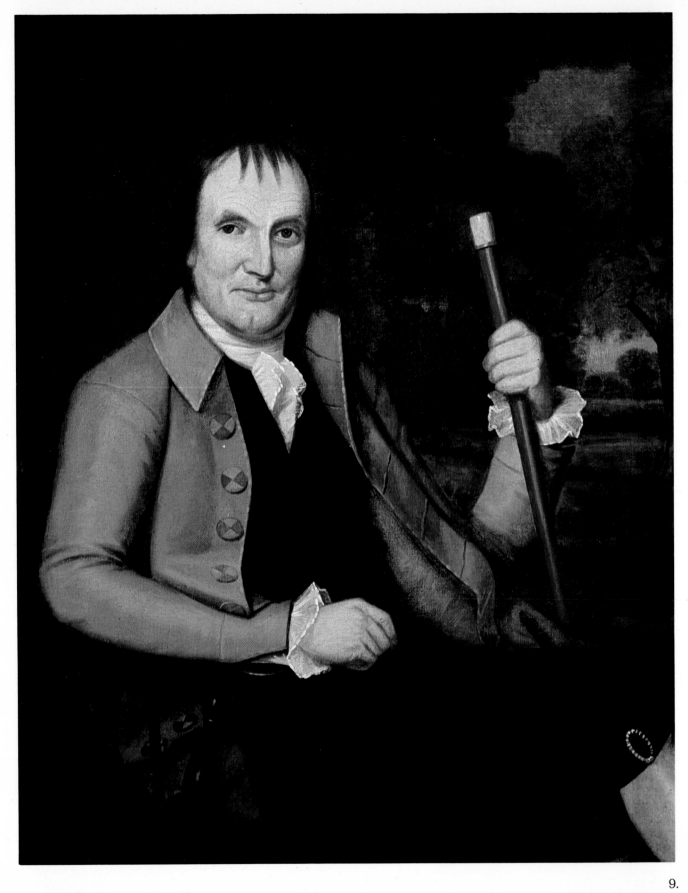

9.

9.

RALPH EARL (1751-1801)
John Nichols
1795, Fairfield County, Connecticut
Oil on canvas, 38 by 30½ (96.5 by 77.5)
Signed and dated in lower left corner: *R. Earl Pinxt 1795*

In companion portraits painted by Ralph Earl in 1795, John Nichols and his wife (catalog entry 10) appear comfortably relaxed and personable, traits noticeably lacking in the stern, austere works of many other early American portraitists.

The sitter in this Earl portrait, John Nichols (1754-1817), was born in Greenfield Hill, Fairfield, Connecticut. After marriage to Mary Hill he settled permanently in nearby Easton. Nichols' considerable land holdings in Easton included meadows, farmlands, woodland, and lots. He also owned a blacksmith shop and had part ownership in a saw mill.[18]

Earl, son of Ralph and Phebe (Whittemore) Earle, was raised in Leicester, Massachusetts; the family background was in crafts and farming. In 1774 he married his cousin, Sarah Gates of Worcester, and set up a studio in New Haven. The source of his early training as a painter is conjectural, but he may have received instruction from Samuel King or William Johnston. From this period in New Haven, Earl is credited with two portraits and four unique paintings of early Revolutionary War activity at Lexington and Concord. The latter have earned him general recognition as America's first history painter.[19]

Earl's stay in Connecticut was brief, for his Tory affiliation forced him to flee the colonies. Leaving his wife behind, he sailed for England, arriving in early 1778; he was to remain there for seven years. Contact with the English academies catalyzed the development of his talents, and he attained greater technical sophistication and painted with a more fluent style. From 1783 through 1785 he exhibited at the Royal Academy.

Upon returning to America in 1785, Earl headed for New York City where he advertised as having spent a number of years in London under the renowned Sir Joshua Reynolds, John Singleton Copley, and Benjamin West. Earl's second wife, Ann Whiteside of Norwich, England, accompanied him. His status with his first wife is a clouded issue, and life with his second seems to have been none too close, since she evidently took up residence away from him, in Troy, New York.

Insolvency landed the heavily drinking Earl in New York's city prison, but while there his talents were still sought after, and Alexander Hamilton even urged his wife to sit for her portrait in the jail. Upon regaining his freedom in 1788, Earl began to travel through Connecticut, accepting portrait commissions from many upper-class citizens. Some paintings from this second American period reflect the sophistication of his work in England. Others, however, such as *John Nichols,* are marked by a retreat to an unpretentious and more direct style.

Provenance:
 Tillou Gallery, Litchfield, Connecticut.

Exhibited:
 Museum of Fine Arts, Boston, *Paintings by New England Provincial Artists 1775-1800,* July 21 to October 17, 1976.

Reference:
 Little, Nina Fletcher. *Paintings by New England Provincial Artists 1775-1800.* Boston: Museum of Fine Arts, 1976.

10.

RALPH EARL
Mrs. John Nichols
1795, Fairfield County, Connecticut
Oil on canvas, 38 by 30¼ (96.5 by 76.8)
Signed and dated at left below window: *R. Earl Pinxt 1795*

Ralph Earl's portrait of Mrs. John Nichols, the former Mary Hill (circa 1756-1844), contains a special note of warmth with the presence of the child seated in her mother's lap. It is assumed that this is Charlotte, who was the eleventh of the Nichols' twelve children and who was born June 7, 1795. Mrs. Nichols is seated indoors, unlike her husband, but the tranquil landscape beyond the window unifies and balances the two portraits (see catalog entry 9). Earl's noted ability for depicting the personalities of his sitters is well exemplified in both portraits.

The Nichols paintings were copied in 1802 by Jonathan Budington, perhaps at the request of a member of the family. Although Budington's talent did not equal Earl's, his copied portraits are quite straightforward, though admittedly rougher; the only major change is the removal of the child,

perhaps because by 1802 Charlotte would have been seven or eight years old.

Provenance:
Tillou Gallery, Litchfield, Connecticut.

Exhibited:
Museum of Fine Arts, Boston, *Paintings by New England Provincial Artists 1775-1800,* July 21 to October 17, 1976.

Reference:
Little, Nina Fletcher. *Paintings by New England Provincial Artists 1775-1800.* Boston: Museum of Fine Arts, 1976.

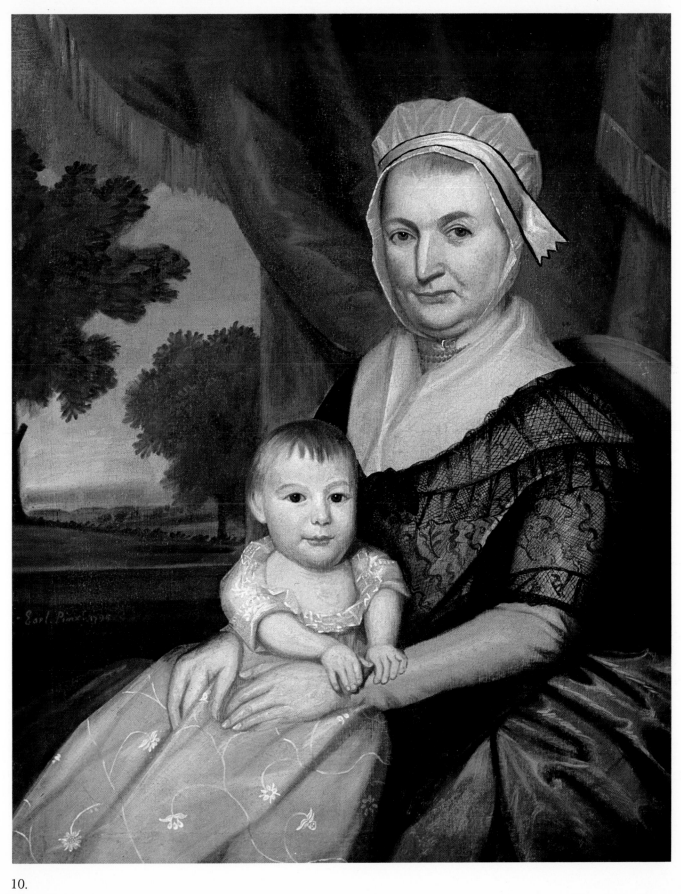

10.

11.

JONATHAN BUDINGTON (1779-1823?)
Child of the Hubbell Family
ca. 1800, Fairfield, Connecticut
Oil on canvas, 24¾ by 19¾ (62.9 by 50.2)

Facts of the life of Jonathan Budington have not been firmly established, but the name is known through six signed portraits and one signed landscape (the Cannon house and wharf in New York City). The portraits originate from the Fairfield, Connecticut area, as does this one. Though unsigned, it is generally attributed to Budington.

Connecticut sources name several Jonathan Budingtons, but there is no evidence linking any of them to the painting profession. However, the origin of the six portraits in the Fairfield area may indicate that the painter Jonathan Budington was the son of one Edward Budington, who was born in Fairfield in 1779 and died there in 1823. Also, a portrait painter bearing the name Jonathan Budington is listed in New York City directories from 1800 to 1805 and again from 1809 to 1812.[20]

The Hubbell family lived in Greenfield Hill, part of Fairfield, Connecticut. Like Mr. and Mrs. John Nichols (catalog entries 9 and 10) of neighboring Easton in Fairfield County, Mr. and Mrs. David Hubbell engaged Ralph Earl to paint their portraits. Thus, Budington twice crossed the path of Earl's career, once when he copied Earl's portraits of Mr. and Mrs. Nichols and again when he painted the Hubbell child, whose parents had previously been painted by Earl.

Provenance:
> Descended in the Hubbell family, Greenfield Hill, Fairfield, Connecticut.
> Florene Maine, Ridgefield, Connecticut.
> Mary Allis, Southport, Connecticut.

Exhibited:
> Abby Aldrich Rockefeller Folk Art Collection, Williamsburg, Virginia, *The Beardsley Limner and Some Contemporaries,* October 15 to December 3, 1972; Montclair Art Museum, Montclair, New Jersey, December 17, 1972 to January 28, 1973; New Haven Colony Historical Society, New Haven, Connecticut, February 11 to March 25, 1973.

Reference:
> Schloss, Christine Skeeles. *The Beardsley Limner and Some Contemporaries.* Williamsburg: The Colonial Williamsburg Foundation, 1972.

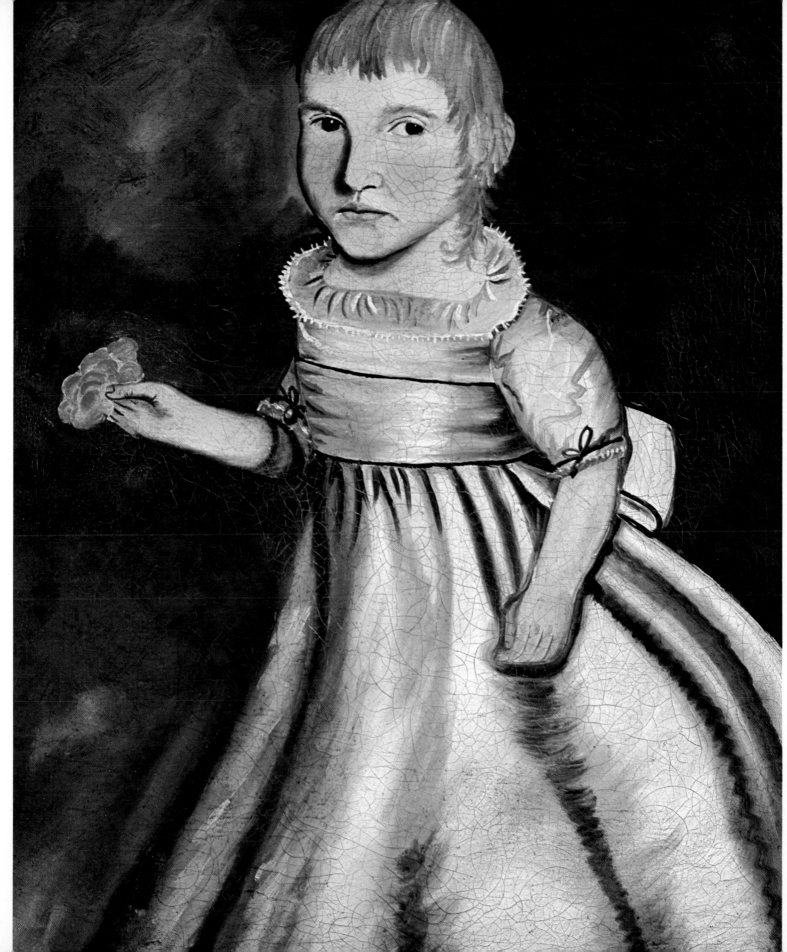

11.

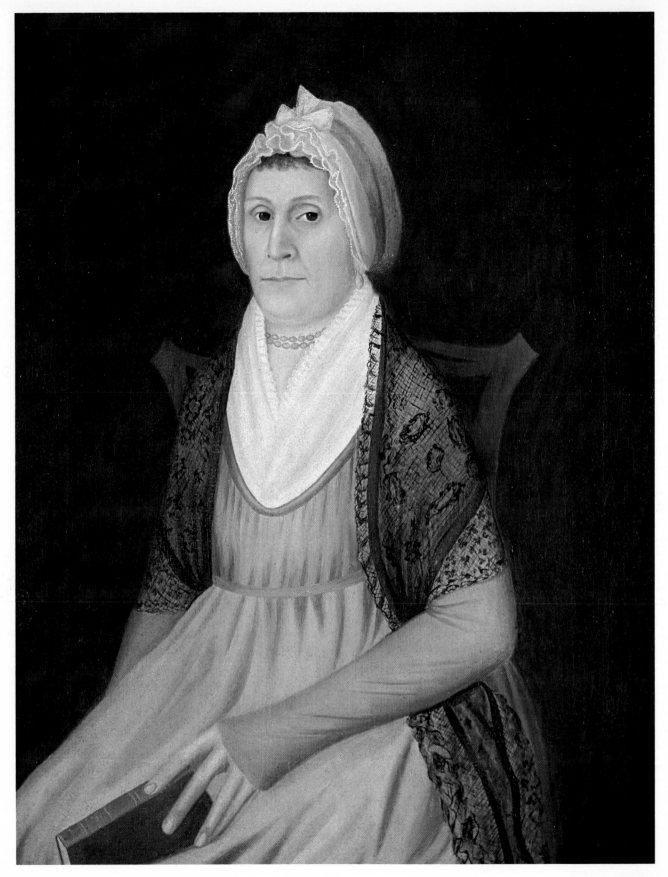

12.

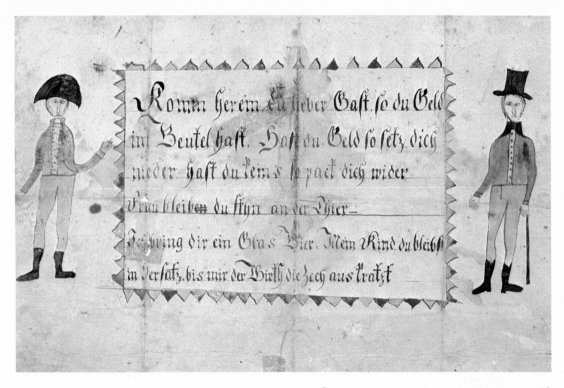

13

12.

ARTIST UNIDENTIFIED
Woman in a Chippendale Side Chair
ca. 1800, Massachusetts
Oil on canvas, 29¼ by 23 (74.3 by 58.4)

A cool sobriety pervades the carefully painted *Woman in a Chippendale Side Chair*. The muted tones used throughout the painting, the spare setting, and the woman's fixed expression all contribute to this effect, which is moderated only by the restrained grace of the black lace shawl and the decorative lacing of the lady's bonnet.

The identities of the artists and subjects of many early American portraits are known through labels and signatures on the paintings, or they have been established through stylistic comparisons and research into written records. Some portraits, however, like *Woman in a Chippendale Side Chair,* remain veiled in mystery regarding the names of the painter and sitter. This painting bears a resemblance to the portraits of General and Mrs. Sloan, ca. 1800, signed "J. Brown/Pinxt," in a private collection, but little is known about this J. Brown, who was one of three artists in New England with the same name.

Provenance:
 Mary Allis, Southport, Connecticut.

13.

ARTIST UNIDENTIFIED
Tavern Rhyme
ca. 1800, Pennsylvania
Watercolor on paper, 10⅞ by 16 (27.6 by 40.6)

In addition to the more common forms of fraktur art, such as the familiar *Taufscheine* (birth and baptismal letters) and *Vorschriften* (writing lessons), scriveners and folk painters in German communities in this country also produced unusual works, such as this tavern rhyme and other rare examples (catalog entries 25 and 26). The crudely drawn but engaging figures, which may represent either the proprietors or tavern guests, flank verses admonishing us that neither credit nor women are admitted in this tavern. This watercolor is from a Berks County, Pennsylvania tavern, and it is the only known example of its type. The amusing verses read:

> Come in, dear guests, if you have money
> in your purse. If you have money sit down,
> if you don't, pick up your things and leave.

> Woman, remain standing at the door—
> I bring you a glass of beer. My child, you
> remain in hock until the innkeeper receives his money.

Provenance:
 Kribel Collection, Reading, Pennsylvania.
 Joe Kindig, Jr. & Son, York, Pennsylvania.

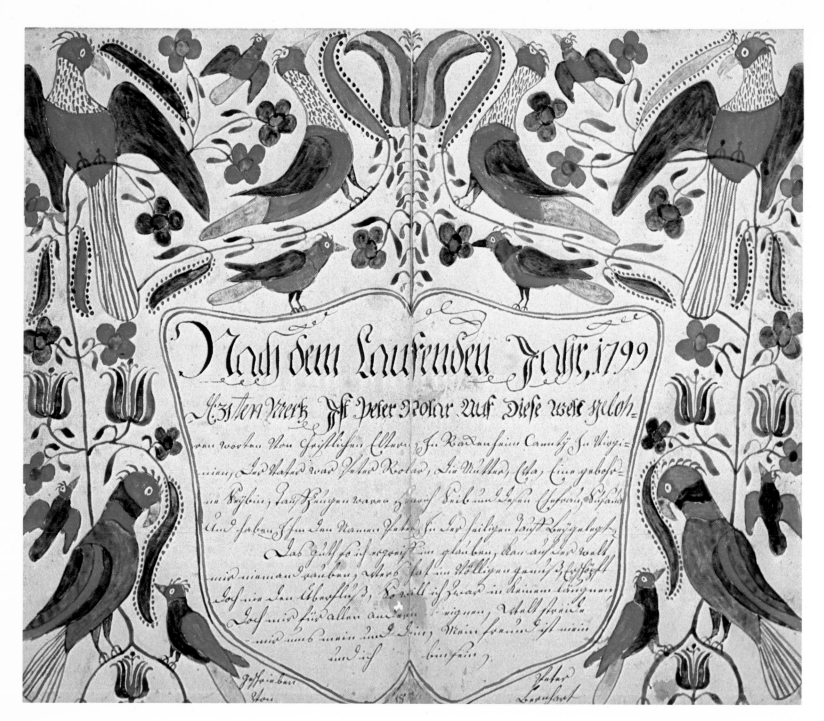

14.

14.

PETER BERNHART
Taufschein for Peter Rolar
1804, Rockingham County, Virginia
Watercolor and ink on paper, 13 by 16 (33 by 40.6)
Signed and dated beneath shield: *Peter/Bernhart/1804*

In addition to Pennsylvania, the Shenandoah Valley of Virginia was one of the major centers of German settlement in North America. By 1790 some 35,000 German-Americans of Rhenish, Alsatian, and German-Swiss descent inhabited the Virginia Valley area. These settlers continued their tradition of making letters or remembrances of the births and baptisms of their children. Commonly called *Taufscheine,* they were usually commissioned by the child's parents, but occasionally they were made by the parents themselves (see catalog entry 15). This example was done for Peter Rolar, who was born in 1799, and was commissioned from the fraktur artist Peter Bernhart. It is one of his finest works.

Documents reveal a few details about Peter Bernhart, who was active in the Shenandoah Valley of Virginia. The earliest record shows that he was a resident of Keezletown, near Harrisonburg, Virginia and that he rode the post route between Winchester and Staunton. He appears to have given up his mail route with the introduction of regular postal service, and in 1810-11 is recorded as a school teacher. His dated fraktur work, which varies sharply in quality, extends over the period 1796 to 1819.[21]

Although Bernhart had no formal training, he knew Freidrich Krebs, the famous fraktur artist from Dauphin County, Pennsylvania, and he even completed some of Krebs' incomplete works and then sold them.[22] It was not unusual for two fraktur artists to collaborate, one working on the script and the other designing the ornamentation, and many examples of dual authorship are known. The *Taufschein* of Peter Rolar, however, appears to be completely by Bernhart's hand. Not only are the decorative motifs and the script of excellent quality for Bernhart, but the imagery is remarkable for the fourteen birds and the distinctive shield form on which the text is inscribed.

Provenance:
 R. E. Crawford Antiques, Richmond, Virginia.

Exhibited:
 Pratt Graphics Center Gallery, New York, *American Fraktur: Graphic Folk Art 1745-1855,* November 19, 1976 to January 8, 1977.
 Abby Aldrich Rockefeller Folk Art Collection, Williamsburg, Virginia, *Virginia Fraktur,* Summer 1974.

References:
 Wust, Klaus. *American Fraktur: Graphic Folk Art 1745-1855.* New York: Pratt Graphics Center Gallery, 1976.
 ———. "Fraktur and the Virginia Germans." *Arts in Virginia* 15 (Fall 1974): 2-11.
 ———. *Virginia Fraktur.* Edinburg, Virginia: Shenandoah History, 1972.

15.

BARBARA BECKER (1774-1850)
Taufschein for Elias Hamman
1806, Shenandoah County, Virginia
Watercolor on paper, 15 by 12½ (38.1 by 31.7)

Like their countrymen in Pennsylvania, the Virginia Germans made remembrances of births and baptisms in the form of frakturs combining script and fanciful ornamentation. Although each artist invented his or her own variations and combinations, basic motifs were shared by all fraktur artists. Hearts, birds, flowers, suns, stars, and angels are among the symbols prevalent in this decorative repertoire. Although motifs such as fleur-de-lis, Masonic symbols, and American patriotic imagery found their way into the frakturs produced in America, most extend from older Germanic and Celtic sources.[23]

This *Taufschein* is for Elias Hamman, the son of Johannes and Barbara Becker Hamman; he was born August 29 and baptized September 21, 1806. It is noteworthy for the excellent quality of the script and drawing. Like many folk artists, fraktur artists usually did not sign their work. However, the calligraphy of this fraktur has been attributed to Barbara Becker, Elias' mother, on the basis of a comparison with a sample bearing the signature of her maiden name. Born in 1774, Barbara Becker received her training in calligraphy in the Strasburg German School. She is known to have produced frakturs as early as 1786, when she was but a girl of twelve.[24]

Provenance:
Edgar William and Bernice Chrysler Garbisch.

Exhibited:
Pratt Graphics Center Gallery, New York, *American Fraktur: Graphic Folk Art 1745-1855,* November 19 to January 8, 1977.
Roanoke Fine Arts Center, Roanoke, Virginia, *A Virginia Sampler,* March 14, 1976 to April 24, 1976.
Abby Aldrich Rockefeller Folk Art Collection, Williamsburg, Virginia, *Virginia Fraktur,* Summer 1974.

Reference:
Wust, Klaus. "Fraktur and the Virginia Germans." *Arts in Virginia* 15 (Fall 1974): 2-11.

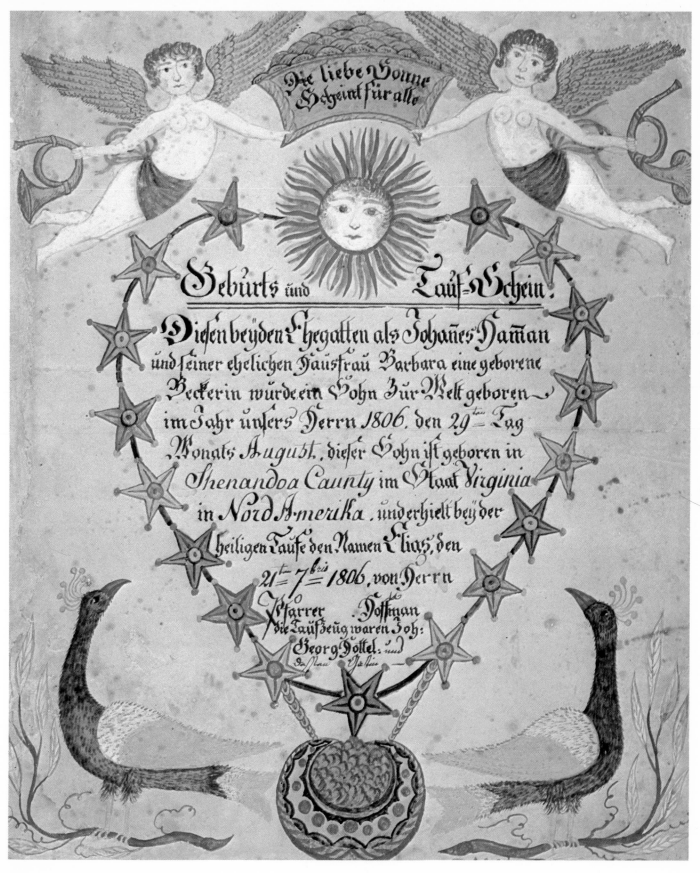

15.

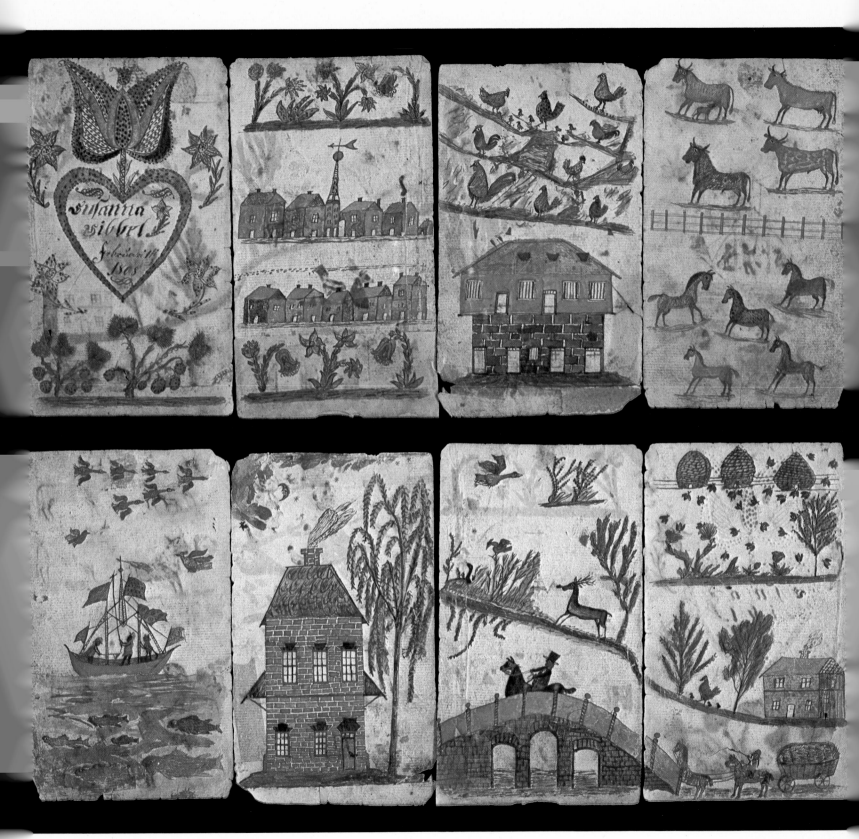

16.

SUSANNA SIBBEL
Four Book Pages (front and back)
1808, Pennsylvania
Watercolor on paper, each page approx. 6½ by 3¾ (16.5 by
 9.5)
Signed and dated on introductory page: *Susanna/Sibbel/
 February 1st/1808*

A gentle world of man and beast is depicted in these unique drawings by Susanna Sibbel. The signature page demonstrates her familiarity with standard fraktur motifs, but beyond that heraldic introduction, her interests lay in picturing the world around her. Domestic and wild animals, man and his creations, and the moon and stars are all part of this pleasant world.

With the difficulty of one who lacked formal training, Susanna Sibbel drew her subjects either in profile or with a sharply rising ground plane. But awkwardness does not stand in the way of charm, and the pollen-gathering bees, the hen walking with her chicks, and even the fork-tongued snake are rendered with great delight. Whether this was done as a school girl's exercise, as a project of her own liking, or for some other reason, remains conjectural, but it is clear that it was done with affection.

Provenance:
 Joe Kindig III, York, Pennsylvania.

Exhibited:
 The Historical Society of York County, York, Pennsyl-
 vania, *The Pennsylvania German Influence*, Summer
 and Fall 1976.

17.

JACOB MAENTEL (1763-1863)
Boy with a Parrot
ca. 1815, Pennsylvania
Watercolor and ink on paper, 6¼ by 7½ (15.9 by 19)

Information about Jacob Maentel is scarce, and many details of his life are either uncertain or unknown. A native of Cassel, Germany, Maentel reportedly studied medicine and served as a secretary to Napoleon.[25] After emigrating to the United States, he lived for a number of years in Pennsylvania and Maryland.[26] Sometime around 1830 he moved west and settled in New Harmony, Indiana, where he died before his one-hundredth birthday.[27]

Maentel's modestly sized portraits, painted in watercolor on paper, originate from all three of the states named above. Until the mid 1820s he depicted his subjects full-length and in profile, showing them either in the interior of a house or walking through the countryside. After this time he represented his subjects full-length, but in three-quarter profile, with either interior or landscape backgrounds. These later paintings are distinctly more elaborate in conception and detail than the earlier ones.

This painting of a young boy is characteristic of Maentel's profile portraits. Common traits of these early works are the juxtaposition of the dominating foreground figure and small landscape, as well as the diminutive proportion of the subject's body in comparison to the head. Maentel frequently added a special touch to his portraits of children by showing them holding a flower or a bird; in this picture, a parrot is perched on the child's hand.

Provenance:
Hovey B. Gleason Antiques, Marietta, Pennsylvania.

18.

ARTIST UNIDENTIFIED
Little Girl in Blue with Apricot
ca. 1815, Connecticut
Oil on panel, 23 by 19¼ (58.4 by 48.9)

Although he is unknown today, the painter of this attractive portrait combined a special inclination for line and a sensitivity to color . The linear element exists primarily in terms of the crisp outline of the girl's profile. It is a remarkably animate outline and entices the eye to follow it. The artist's talent as a colorist is evident in his use of light colors, which are fitting for a young girl, and in the tonal interplay among the auburn hair, blue dress, and bright orange of the apricot. To depict the highlights and shadows of the girl's dress, the artist blended the different shades of blue by means of broad brushstrokes, which successfully complement the vitality of the crisply drawn profile.

The talent exhibited by this artist would seem to indicate that he was more than a casual painter. His keen powers of observation are evident in the youthful chubbiness of the girl's features and the freshness of the colors. But to date no other works are attributed to this artist. A location in Connecticut is possible; it has been suggested on the basis of the oval format, which was popular in that New England state.[28]

Provenance:
Kennedy Galleries, Inc., New York.

Exhibited:
Kennedy Galleries, Inc., New York. *American Naive and Folk Art of the Nineteenth Century,* January, 1974.

Reference:
Kennedy Galleries, Inc., New York, "American Naive and Folk Art of the Nineteenth Century." *The Kennedy Quarterly* 13 (January 1974).

19.

ARTIST UNIDENTIFIED
Amasa Gaillard Porter
1814, New Hampshire
Oil on canvas, 18 by 15¾ (45.7 by 40)

This cheerful portrait bears a label on the back identifying the young boy as Amasa Gaillard Porter and dating it 1814. Unfortunately the artist is not also identified. A similar portrait of a young boy with a ruffled collar and a book (in a private collection) is identified as Henry Bliss Porter, probably Amasa's brother; a label mounted on the back dates this painting 1812.[29]

Amasa is pictured in an attentive attitude, with his thumb marking a page in the book. The use of bright colors is fitting to the boy's age, and the cheerful rose of his cheeks and lips nicely complements the blue background.

Provenance:
R. L. Mills, Exeter, New Hampshire.
Crawford and Goodman Antiques, Richmond, Virginia.

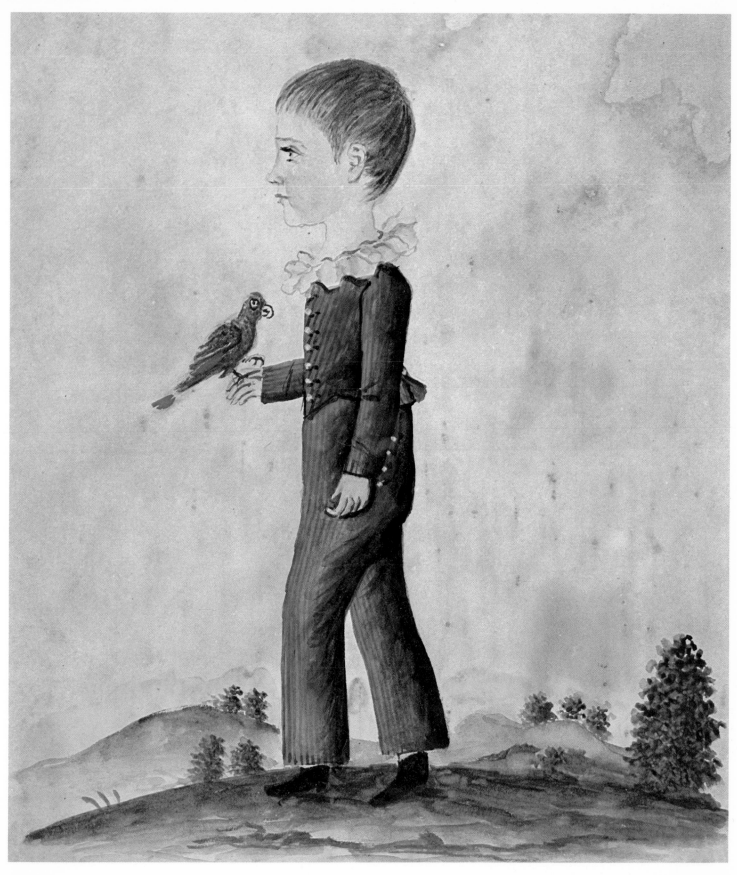

17.

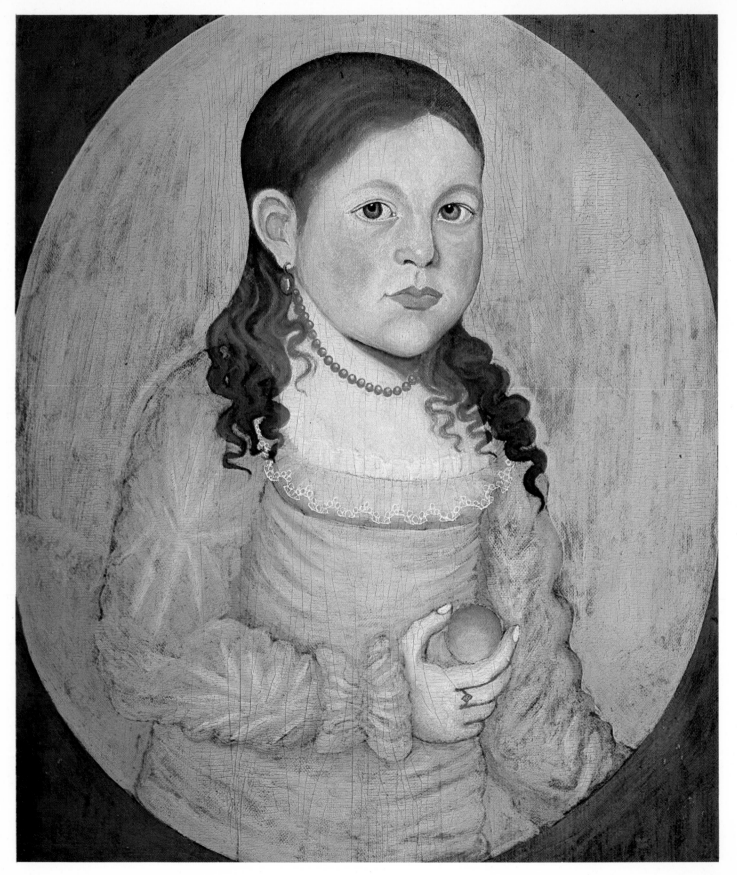

18.

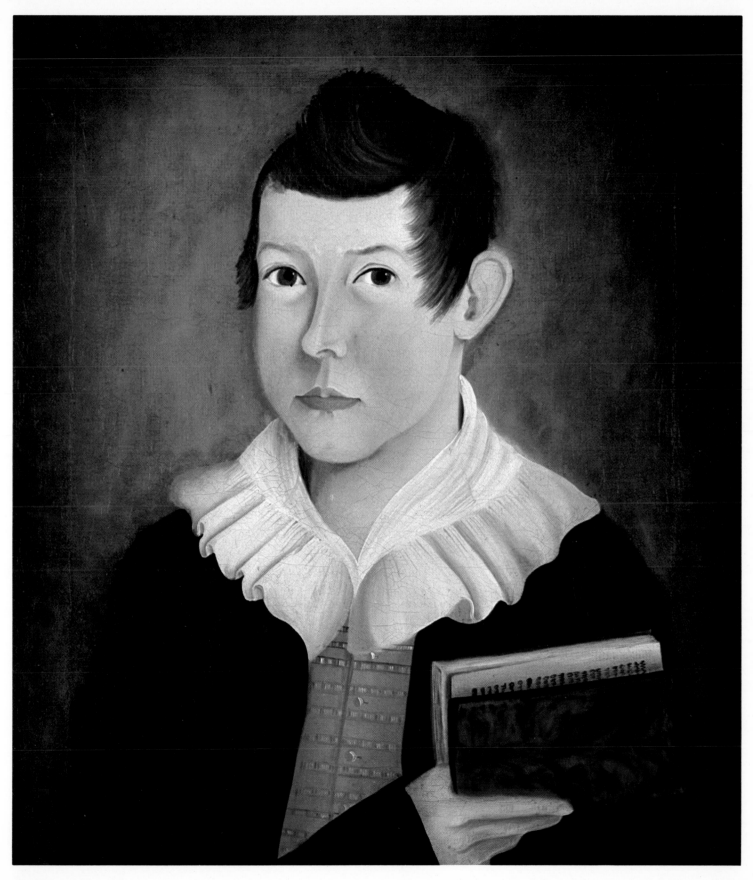

19.

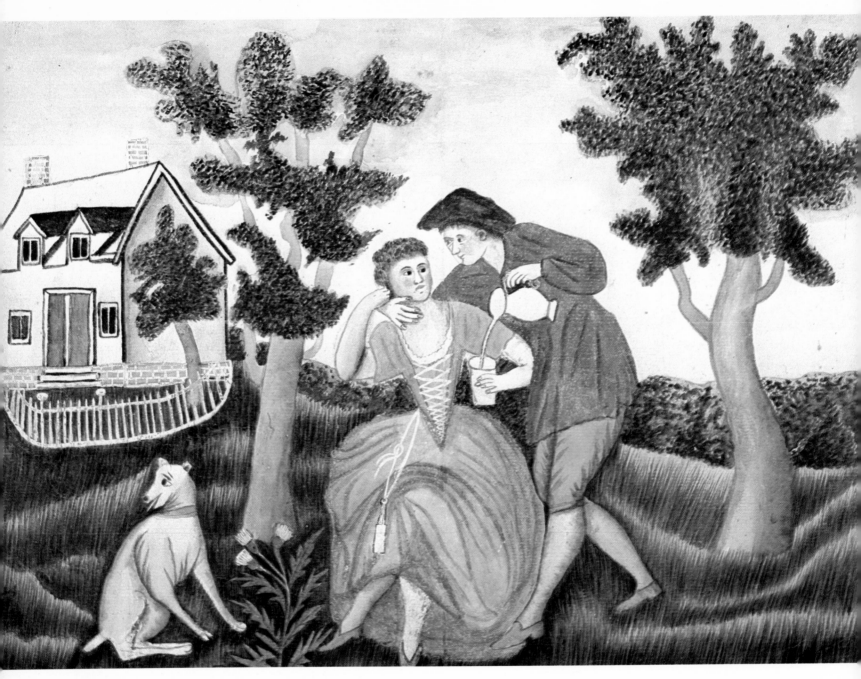

20.

EUNICE PINNEY (1770-1849)
A Couple in a Landscape
ca. 1815, Connecticut
Watercolor on paper, 11⅜ by 15½ (28.9 by 39.4)

Eunice Griswold Pinney was the fourth of eight children of Elisha and Eunice Griswold of Simsbury, Connecticut. She was married twice—first to Oliver Holcombe of Granby, Connecticut, who died in 1796 or 1797, and second, in 1797, to Butler Pinney of Windsor, Connecticut. During her first marriage she gave birth to two children, and she bore three children during her second marriage.[30]

Pinney did not begin painting until about 1809, and she stopped her artistic endeavors about 1826.[31] Today, more than fifty paintings by her are known, most of which were executed in the towns of Simsbury and Windsor. Her works depict a great variety of subjects, such as landscapes, buildings, memorials, allegories, and religious, historical, and literary scenes. She also painted figural compositions, of which *A Couple in a Landscape* is noteworthy for its exuberance. It also is large in size in comparison to many of her other works.

Lack of formal training did not deter Pinney from painting with an energetic style or from endowing her work with a lively spirit. In this regard, her paintings are distinct from the more genteel work of many nineteenth-century female artists, who received their training in female academies and seminaries. Her personal formula for depicting grass by means of many slender strokes and ridges of yellow is a characteristic present in some of her other paintings, such as *Children Playing,* circa 1815, in the Abby Aldrich Rockefeller Folk Art Collection. This painting is also lively in spirit, like *A Couple in a Landscape.*

Pinney is known to have based some of her paintings on English aquatints and woodcuts.[32] The central figures in this watercolor are painted in a larger scale than their environment and might be derived from a similar European source. The robust embrace of the man, the motif of pouring from a pitcher into a glass, and the animated facial expressions, which are touched with humor, are especially reminiscent of certain eighteenth-century Dutch and English genre scenes.

Provenance:
Gunn Collection.
Mary Allis, Southport, Connecticut.
Edgar William and Bernice Chrysler Garbisch.

Exhibited:
Whitney Museum of American Art, Downtown Branch, New York, *19th Century American Women Artists,* January 14-February 25, 1976.

Reference:
Bernstein, Judith, et. al. *19th Century American Women Artists*. New York: Whitney Museum of American Art, 1976.

21.

ARTIST UNIDENTIFIED
Sewell Fisk
ca. 1820, Boston, Massachusetts
Oil on panel, 26¼ by 21½ (66.7 by 54.6)

Sewell Fisk was a retired master of the Naval Masonic Lodge in New York. His Masonic pin is plainly visible amidst the ruffles of his collar. After that lodge closed, he became first master of the newly formed Mariner's Lodge. Mr. Fisk evidently had ties to Boston, for his portrait also shows him wearing the uniform of the Washington Artillery of that city.

The portrait, painted by an unidentified artist, is characterized by a striking tan tonality and by spontaneous brushwork in the delineation of the face. In addition, before starting to paint, the artist scored the panel with fine grooves running diagonally across the surface. The texture thus created enriches the otherwise cold surface of a smooth panel. Gilbert Stuart customarily scored his mahogany panels on the diagonal by planing the surface with a notched blade in order to simulate the effects he obtained on twilled canvas, his preferred painting surface.[33] In a similar manner, Zedekiah Belknap scored the surfaces of the panels for his portraits of the Warren family (catalog entries 27, 28, and 29).

Provenance:
Edith Gregor Halpert, New York.

Exhibited:
Mirski Gallery, Boston, Massachusetts, May 1953.
Downtown Gallery, New York, New York, October 1944.
Denver Art Museum, Denver, Colorado, May 1936.
The Detroit Institute of Arts, Detroit, Michigan, *American Folk Art and Colonial Furniture,* October 15 to November 12, 1935.

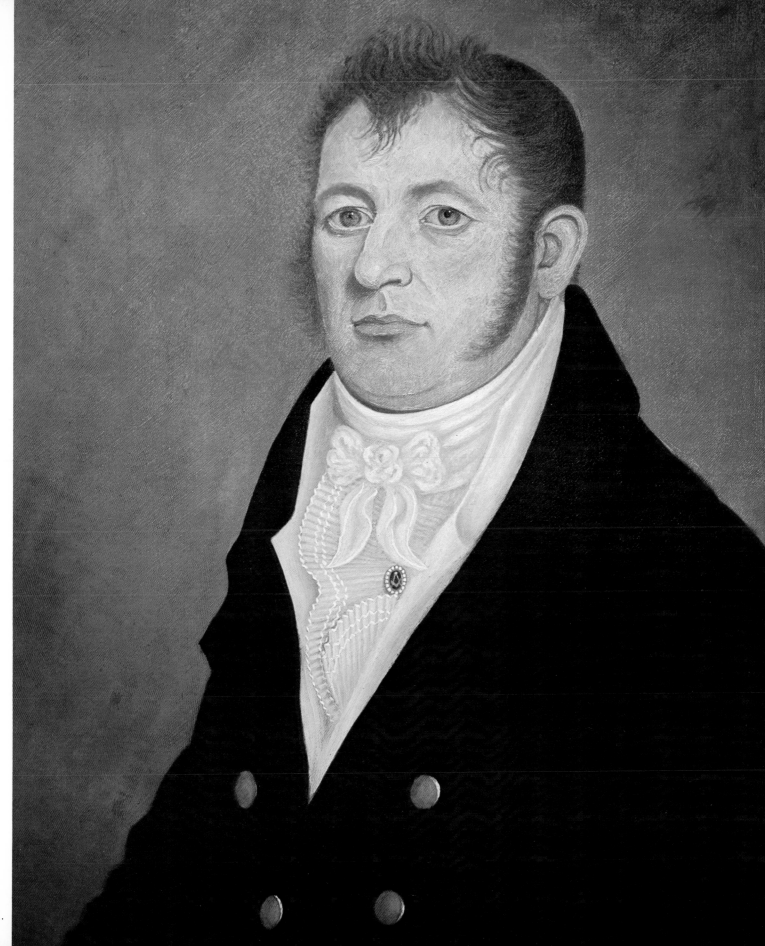

21.

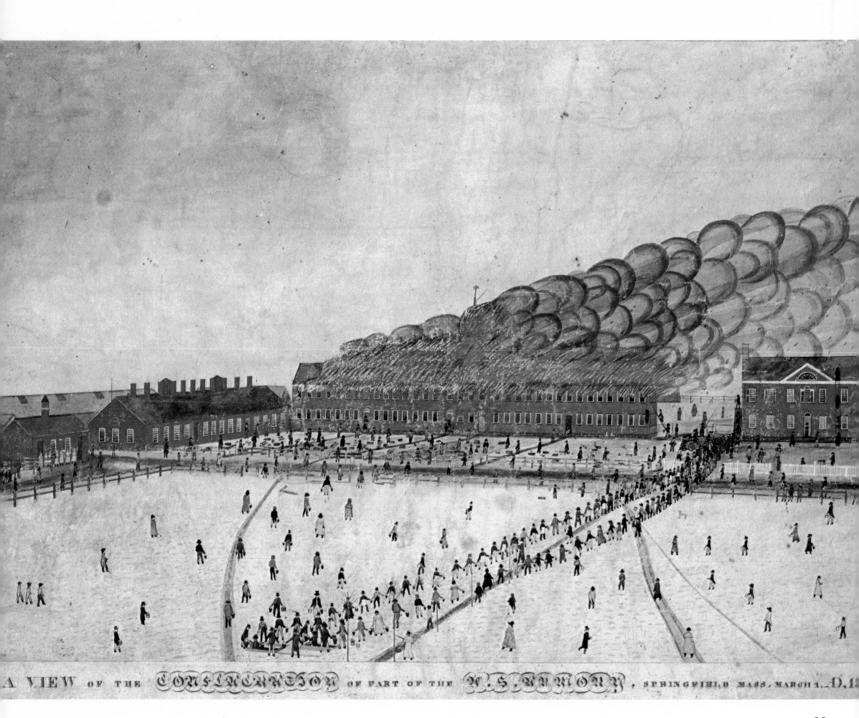

A VIEW OF THE CONFLAGRATION OF PART OF THE U.S. ARMOUR, SPRINGFIELD MASS. MARCH 1. A.D. 1…

22.

22.

ARTIST UNIDENTIFIED
A View of the Conflagration of Part of the U. S. Armory,
 Springfield, Mass. March 2, AD. 1824.
1824, Springfield, Massachusetts
Watercolor on paper, 19 by 27½ (48.3 by 69.9)

The Springfield Armory dates back to 1777 when it was a warehouse for the storage of armaments. Actual manufacture of arms was begun there in 1795 and reached its greatest renown early in the twentieth century with the development of the Springfield rifle in 1903. For thirty years the Springfield served as the basic infantry weapon of the U. S. Army. The armory was closed in 1968 and is now a museum.

Hope of extinguishing the blaze in the long building was apparently abandoned in favor of saving the adjacent structure by means of a bucket brigade and a manual pumper. Gutted but not destroyed, the long building was later rebuilt and was eventually connected to the building on the right. The artist animated the conflagration scene with details of the rescue of rifles from the flame-engulfed building. He even added a humorous touch, by showing a dog satisfying his curiosity about the fire in an open doorway.

The paper is Whatman and was made in 1821. A related watercolor of the fire, though smaller in size, is in the collection of the Springfield Armory Museum.

Provenance:
 Dana Tillou, Buffalo, New York.

23.

23.

AMMI PHILLIPS (1788-1865)
Man with a Large Bible
ca. 1824, New York
Oil on canvas, 30¾ by 25 (78.1 by 63.5)

In 1770, Samuel Phillips and his family moved from the coastal town of Milford, Connecticut to be among the first settlers of Colebrook in the northwestern sector of the state. There, eighteen years later, Ammi Phillips was born to Samuel and Milla Kellogg Phillips, Jr. The small town of Colebrook lies not far from the Connecticut, Massachusetts, and New York tri-state border region that was to become familiar territory to Ammi Phillips during his long career as a portrait painter. Little is known about Phillips' childhood, but by 1811-12 he had painted several respectable portraits of residents in the vicinity of the Massachusetts-New York border.[34]

In 1813 Phillips married Laura Brockway of Schodack, New York, and they moved to Troy in Rensselaer County, New York. Because of his popularity and the demands of his profession, he must have been away from home frequently. Between 1813 and 1820 he carried out many portrait commissions in New York's Rensselaer, Columbia, Dutchess, and Greene Counties, and in towns in the westernmost reaches of Massachusetts and Connecticut. From 1820 to 1826 Phillips ranged further west and south in New York, working in Schoharie, Chenango, Delaware, Ulster, and Orange Counties. He later returned to work along the Massachusetts and Connecticut borders, remaining there until the mid 1830s. A bill of sale shows that by 1828 Phillips had moved his residence to Rhinebeck in Dutchess County.

Phillips' wife died in 1830, leaving him to care for four sons and a daughter. Within five months, he married Jane Ann Caulkins of Northeast, New York. During 1835 and 1836 Phillips painted many portraits in western Connecticut, especially in the Housatonic River town of Kent. He then resumed traveling more widely to fulfill commissions in all three states. In 1840 his second wife gave birth to a daughter. From 1838 until 1842 he owned land in Amenia, Dutchess County, New York. Later, they apparently moved to Northeast, New York, before finally settling in Berkshire County, Massachusetts in the 1860s.

Phillips was a prolific painter throughout his long career, and the more than 300 portraits accounted to him today attest to his popularity. Apparently he did not have to go knocking on many doors to find work. Rather, doors were often opened for him through references made by clients to families and friends. Although the volume of work enabled him to live comfortably, it did not make him rich.

Phillips' talent for creating both a powerful portrait image and a smooth, attractive painting is evident in this portrait of a man holding a large Bible. The style is crisp and linear, but the resulting rigidity is softened by the sleek paint surface throughout most of the picture. Phillips concentrated on the facial features, conveying an intensity of expression, but he rendered other anatomical features in less detail. This handsome portrait and its companion (catalog entry 24) date from the years when he worked west and south of the familiar border region and when his maturing style accentuated severity and contrasts of light and dark.

Provenance:
 Tillou Gallery, Litchfield, Connecticut.

24.

AMMI PHILLIPS
Woman with a Shawl and Bonnet
ca. 1824, New York
Oil on canvas, 30½ by 25¼ (77.5 by 64.1)

The history of the research involving Ammi Phillips' career has the elements of a classic detective story, one in which only a few clues were originally available. In 1924, a group of portraits by the same artist were noticed in a local exhibition in Kent, Connecticut. Due to the lack of a signature or inscription, the artist came to be called the Kent Limner. Portraits in a different style were found in the New York, Connecticut, and Massachusetts border region, and their unidentified painter was named the Border Limner. In addition, a portrait painter named A. Phillips was known from genealogical and local historical sources in New York. In the 1950s and 1960s, some surprising connections were discovered to exist between the three, and eventually the Kent Limner, the Border Limner, and A. Phillips proved to be one and the same: a native of Colebrook, Connecticut named Ammi Phillips.[35]

An aspect of Phillips' career that became apparent in the course of this detective work was his remarkable shifting of styles. Portraits from what is now known as his Border Period, roughly 1812 to 1819, are characterized by a light, colorful palette and charming simplicity. The Kent pictures, executed circa 1835 to 1836, show a more graceful stylization and deeper tonalities. This is especially true of many of his portraits of women, whom he pictured with a pronounced forward lean and with long, slender necklines.

By contrast, the subjects from the 1820s, as demonstrated by *Woman with a Shawl and Bonnet,* are rigidly posed and severe in expression. In this work, the prominent dark tones characteristic of many Phillips portraits from the 1820s are broken by the colorful banding on the shawl and the delicately detailed bonnet, both of which are rendered with painstaking care. As in *Man with a Large Bible* (catalog entry 23), the smooth paint surface moderates the severity of the woman's facial features and complements the planar quality of the composition.

Provenance:
Mr. and Mrs. Peter H. Tillou, Litchfield, Connecticut.
Mary Allis, Southport, Connecticut.

Exhibited:
The William Benton Museum of Art, The University of Connecticut, Storrs, Connecticut, *Nineteenth-Century Folk Painting: Our Spirited National Heritage,* April 23 to June 3, 1973; The New York State Historical Association, Cooperstown, New York, July 1 to September 5, 1973; Abby Aldrich Rockefeller Folk Art Collection, Williamsburg, Virginia, October 13 to December 1, 1973.

Reference:
Tillou, Peter H. and Paul F. Rovetti. *Nineteenth-Century Folk Painting: Our Spirited National Heritage.* Storrs, Connecticut: The William Benton Museum of Art, 1973.

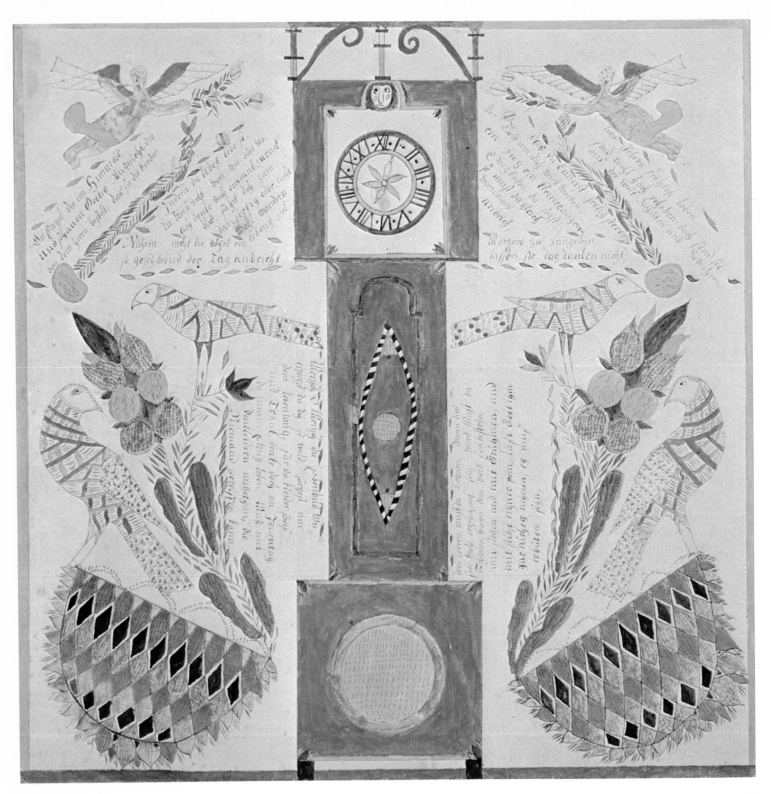

25.

25.

ARTIST UNIDENTIFIED
Spiritual Chimes Drawing
First quarter of the 19th century, Pennsylvania
Watercolor on paper, 12¼ by 12½ (31.1 by 31.7)

Religious verses prompted fraktur artists to create several different types of subjects. This unsigned *Spiritual Chimes Drawing,* so named after the grandfather clock motif, is a particularly rare example. Only one other *Spiritual Chimes Drawing* is known today, and it is signed "E.M.M."[36] The clock in each of these frakturs is so similar that attribution of the art work to the same hand would not seem implausible. However, differences in the calligraphy indicate that the verses were set down by different writers. The following translation has been offered by Klaus Wust:

> The angels who in heaven's light
> merrily praise Jehovah
> and beholding God's countenance
> they have been raised high
> but yet they were ordered by the Lord
> that they protect and guard the children of the world.
>
> In living, live in such a way
> that you'll be saved when you die.
> You do not know when, how, or where
> death will court you.
> Oh, think back for once,
> a trifle, a small moment
> leads you to eternities.
> If you are ready or not,
> you must at once get underway
> when your life's goal is dawning.
>
> Do not the little birds stir
> their little tongues in the morning

> as soon as the day breaks?
> They do not tire of thanksgiving.
>
> Human, oh human, you image,
> how savage you prove yourself
> and worry only all life long
> about dress, food, and drink.
> Think once about that day
> when one must live eternally,
> clad in the dress
> that nobody can tear.
>
> In the Lord you must trust
> if you want to fare well.
> His work you must look upon
> if your work should stand up.
> With sorrow and with grief
> and even one's own pain,
> God does not grant anything
> unless it has been prayed for.

Note: In the translation, the original spacing has been modified to conform to the rhyme scheme in the German. In addition, the punctuation has been altered to improve the readability of the poem.

Provenance:
Edgar William and Bernice Chrysler Garbisch.
Walter G. Himmelreich, Strasburg, Lancaster County, Pennsylvania.

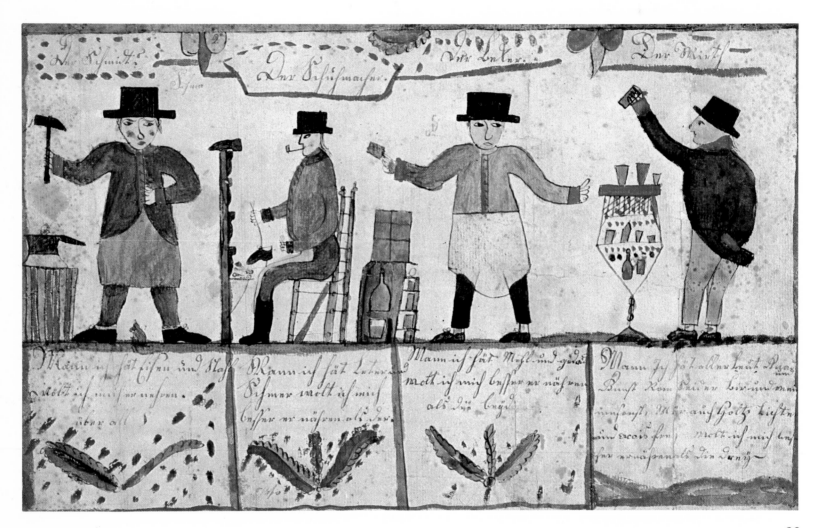

26.

26.

ARTIST UNIDENTIFIED
Four Tradesmen
First quarter of the 19th century, Pennsylvania
Watercolor on paper, 7½ by 12½ (19 by 31.8)

German communities in the New World maintained devoutly religious attitudes, and most of their frakturs include passages from the Scriptures or religious verses. Occasionally, however, fraktur artists turned their efforts to secular subjects, such as the tavern rhyme seen in catalog entry 13 and this depiction of four tradesmen. The unidentified artist showed the smith, the shoemaker, the baker, and the innkeeper, who spiritedly boast the merits of their own trades. In these sketchy vignettes, we can detect the simplicity of dress and surroundings of these good-natured people.

The accompanying verses have been translated by Klaus Wust as follows:

If I had iron and steel,
I could make a living everywhere.

If I had leather and blackball,
I could make a better living than he.

If I had flour and yeast,
I could make a better living than both of them.

If I had the favor and custom of all people
and cider, beer and wine for free,
If also wood, lights and [?] were free
I could make a better living than the three.

Provenance:
Edgar William and Bernice Chrysler Garbisch.

27.

ZEDEKIAH BELKNAP (1781-1858)
Ralph Warren
1829, Townsend, Massachusetts
Oil on panel, 27 by 22½ (68.6 by 57.2)

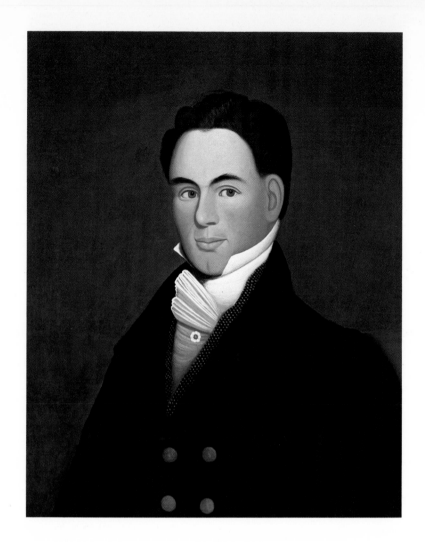

An old paper label on the back of this painting identifies the sitter as Ralph Warren, Esq. of Townsend, Massachusetts and dates the work to 1829. But about the portraitist it says no more than "by a strolling Artist, name unknown." The style with which Mr. Warren is depicted, however, serves as signature enough to identify the "strolling Artist" as Zedekiah Belknap, an itinerant portraitist who was active in New England during the first half of the nineteenth century.

Belknap was a son of Zedekiah and Elizabeth Wait Belknap of Ward (now Auburn), Massachusetts. In 1794, when the younger Zedekiah was thirteen, the Belknaps moved to a farm in Weathersfield, Vermont, where two brothers of the elder Zedekiah were farmers. Of all the Belknap children, only Zedekiah, Jr. was excused from working on the family farm so that he could attend college. He enrolled at Dartmouth College, where he studied divinity, and he graduated with the class of 1807. Although he was never ordained, family genealogy records Zedekiah as a chaplain in the War of 1812.[37]

Except for his brief chaplaincy during the war, Belknap devoted himself to painting portraits in small towns in New Hampshire, Vermont, and Massachusetts. His itinerant career spanned approximately forty years, and he evidently was quite popular. About 150 portraits signed by or attributed to him are known today; the earliest and latest dated works are inscribed 1810 and 1848, respectively. Thus, the confidently painted portraits of Ralph Warren and his wife and son (catalog entries 28 and 29) date from the middle years of Belknap's career.

In 1812, Belknap married Sophia Sherwin in Waterville, Maine. Their marriage evidently was of short duration and left Zedekiah in sorrow, but reports are conflicting. According to the Belknap family, Sophia died in 1815, whereas records at Dartmouth indicate that she left him when she discovered that most of his family was afflicted with lameness due to a hereditary hip disease. In the late 1840s Belknap retired to the family farm in Weathersfield and then in 1857, the year before his death, he went to the Chester Poor Farm.

Provenance:
Bihler and Coger, Ashley Falls, Massachusetts.

Reference:
Mankin, Elizabeth R. "Zedekiah Belknap." *Antiques* 110 (Nov. 1976): 1056-70.

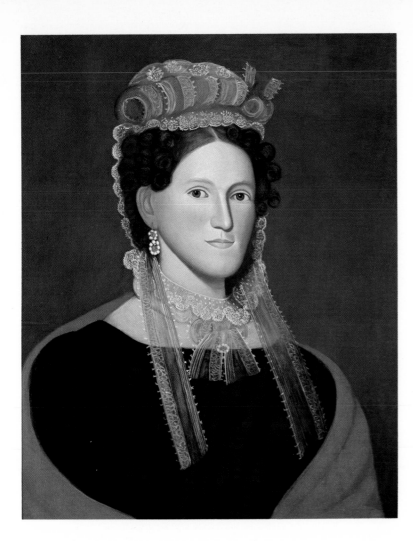

28.

ZEDEKIAH BELKNAP
Beky Sherwin Warren
1829, Townsend, Massachusetts
Oil on panel, 27 by 22½ (68.6 by 57.2)

As with the portraits of her husband and son (catalog entries 27 and 29), Beky [sic] Sherwin Warren of Townsend, Massachusetts is identified by an old paper label attached to the back of the painting. The label also dates the portrait 1829 and attributes it only as being "by a strolling Artist, name unknown."

Despite the lack of a signature, this and the other two Warren portraits are without doubt the work of Zedekiah Belknap, whose crisp style, love of delicate ornament, and attentively posed sitters are aptly displayed in each painting. Belknap customarily positioned his sitters at a slight angle to the picture surface, though they appear to gaze directly out at the viewer. He also illuminated their features with a strong light source, which casts pronounced shadows along the profile of the nose and underneath the chin. In rendering highlights in the portraits of Mr. and Mrs. Warren, he built up the paint rather thickly around the forehead. Otherwise, his handling of paint is smooth and spare throughout, and is particularly delicate in the lacework of Mrs. Warren's bonnet and collar.

It is not known whether Belknap received formal training as a painter, but while at Dartmouth he may have come into contact with contemporary artists. In his earliest portraits, dating from 1810-12, he attempted to work in an academic style. Some of these early compositions are fairly complex in that they include arms, hands, and most of the sitter's torso. But Belknap quickly settled on a simpler format, in which he deleted much of the sitter's torso, thereby eliminating the problem of rendering hands and arms. This more direct style is further characterized by ornamental detail, crisp linearity, and bright highlights and shadows with little intermediate tonal gradation. Although the sitters retain their own individuality, Belknap generalized their facial features and painted them with careful precision, imparting a cool, timeless immobility to their portraits.

Belknap occasionally painted on twilled canvas, but he preferred to work in oil on panel. Most of his panels, including the Warren portraits, are scored with series of fine diagonal grooves to create the effect of a painting on twilled canvas.

Provenance:
Bihler and Coger, Ashley Falls, Massachusetts.

Reference:
Mankin, Elizabeth R. "Zedekiah Belknap." *Antiques* 110 (Nov. 1976): 1056-70.

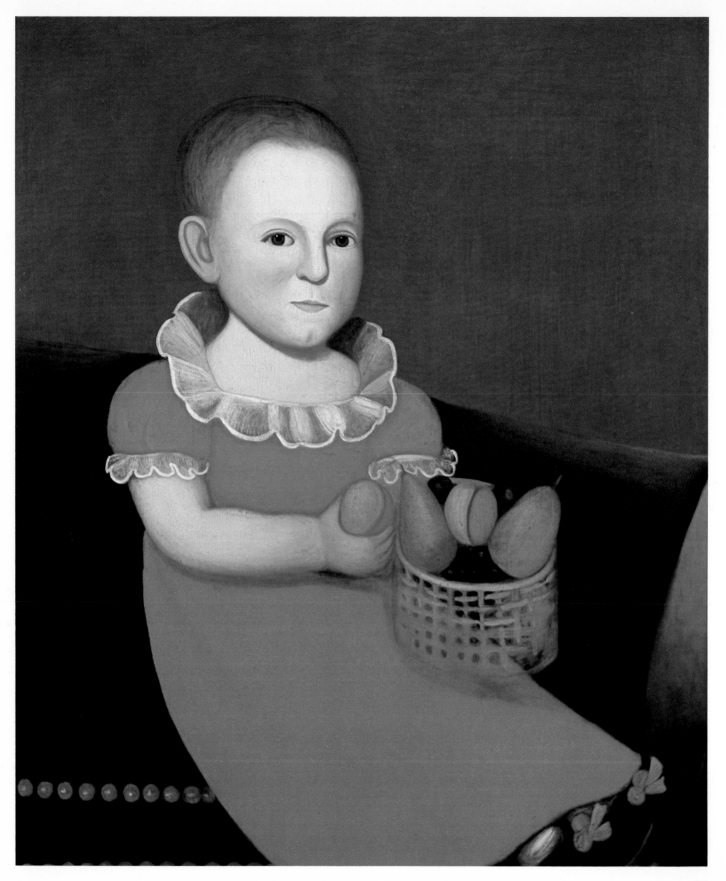

29.

29.

ZEDEKIAH BELKNAP
Dorman Theodore Warren
ca. 1829, Townsend, Massachusetts
Oil on panel, 27¼ by 22½ (69.2 by 57.2)

The label on the back of Dorman Theodore Warren's portrait, like those on the portraits of his parents (catalog entries 27 and 28), is the only source of information about the painting. The label reads: "Dorman Theodore Warren,/ Born 1827./Painted about 1829 by a strolling Artist, in 2 weeks, Townsend, Mass." This portrait is of interest both for its artistic merit and because of the child's tender age, and it makes a charming addition to the portraits of his parents. The three portraits appear to have been conceived as a unified group, since Belknap painted them with matching green backgrounds, though Dorman's is a shade lighter; he also placed each sitter on a burgundy chair or couch. The child wears a bright red outfit, and Belknap used a softer, less severe touch than he did in the portraits of the parents.

Itinerant painters served the portrait needs of New England residents outside the urban reaches of Boston, where academically trained artists competed for the market. Belknap was one of the most popular of these traveling, or "strolling," artists. He portrayed family, friends, and neighbors in the Weathersfield-Springfield area of Vermont; in other small New England towns he worked primarily for middle-class patrons such as innkeepers, farmers, and smiths.[38] His long and prolific career lasted until the time when photography began to compete with the domain of the portrait painter.

Provenance:
Bihler and Coger, Ashley Falls, Massachusetts.

Reference:
Mankin, Elizabeth R. "Zedekiah Belknap." *Antiques* 110 (Nov. 1976): 1056-70.

30.

ELIZABETH GLASER
Lady in a Yellow Dress Watering Roses
ca. 1830, Maryland
Watercolor on paper, 9¾ by 7¾ (24.8 by 19.7)

Elizabeth Glaser evidently lived in Baltimore or its environs, for several of her works bear inscriptions naming that city or the suburb of Fredericktown. In addition to her watercolors and drawings, she is also known for needlework and original verses, and all of these reflect the artistic training common to female academies of the time. In this watercolor, the use of bright colors, the interplay of paper surface and applied color, and the calligraphic nature of the drawing give her work an overall visual appeal. Glaser's captivating style depends on the combination of refined draughtsmanship and broad areas of striking color. With a few economical strokes she has conveyed a preoccupied expression on the young lady, who dreamily waters her roses.

Provenance:
 R. L. Mills, Exeter, New Hampshire.
 Kennedy Galleries, Inc., New York.

Exhibited:
 Kennedy Galleries, Inc., New York. *American Naive and Folk Art of the Nineteenth Century* (January 1974).

Reference:
 Kennedy Galleries, Inc. "American Naive and Folk Art of the Nineteenth Century." *The Kennedy Quarterly* 13 (January 1974).

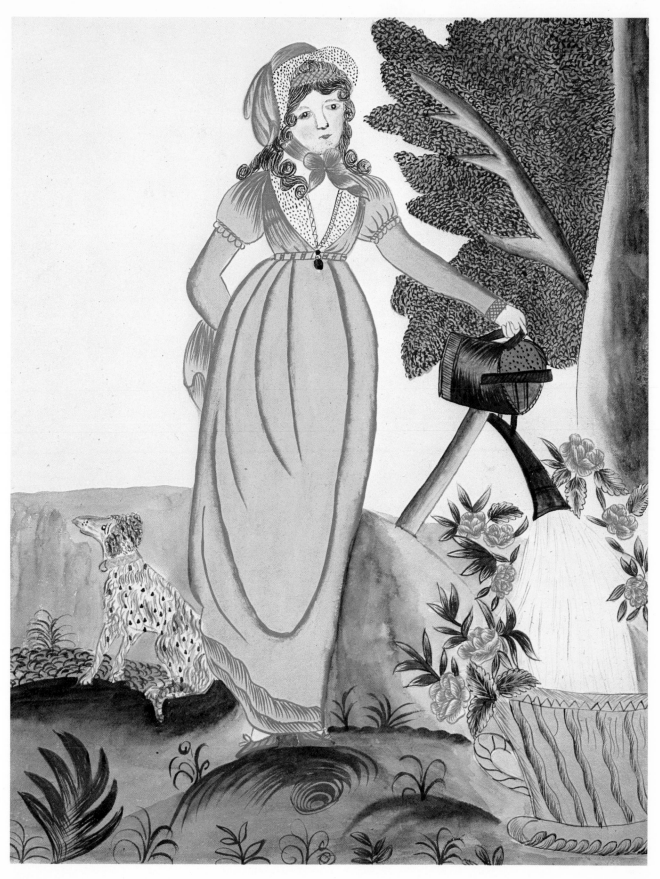

30.

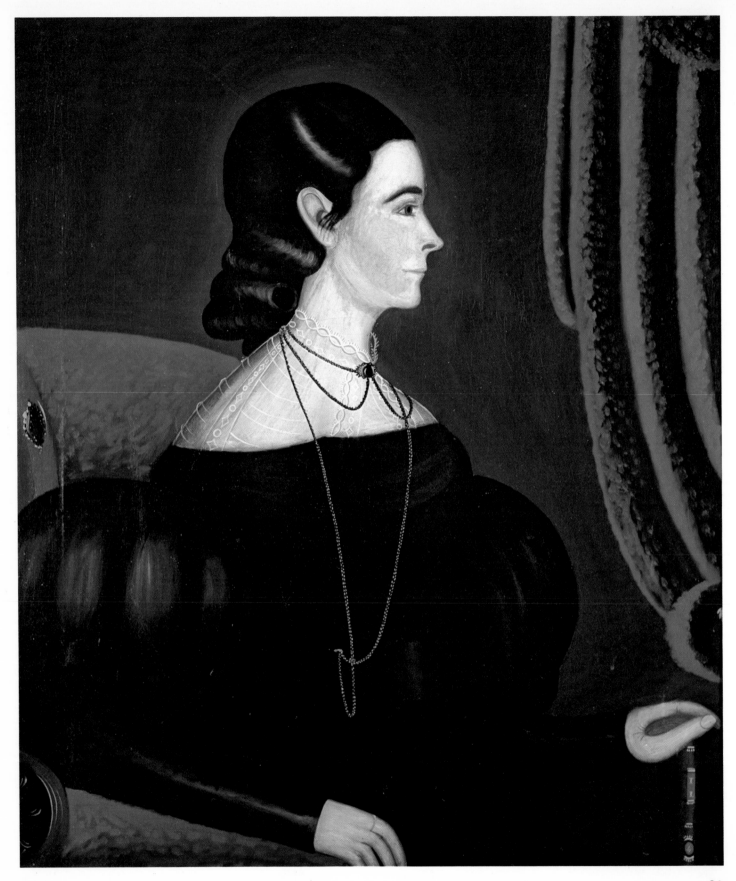

31.

THE BORDEN LIMNER
Profile Portrait of a Lady
ca. 1831-33, New England
Oil on bed ticking, 34⅛ by 29⅛ (86.7 by 74)

The Borden Limner is the name that was given in the late 1960s to the unidentified artist who painted a group of portraits in New England between 1828 and 1835. The name derives from his portraits of Captain Daniel C. Borden and his wife Mary B. Jenney Borden, circa 1834, now in the collection of the Old Dartmouth Historical Society. To date, nearly thirty portraits have been attributed to the Borden Limner, all of them painted in the area of New England bounded on the north by Portsmouth, New Hampshire and on the south by Providence, Rhode Island.[39]

The Borden Limner's style is characterized by a degree of abstraction in all areas but the sitter's facial features, which are rendered with greater naturalism. Except for a single painting of two children, his portraits depict adults, most of them companion portraits of husband and wife. The sitters are usually pictured facing slightly to one side, and the furniture on which they sit is painted in a simplified manner. The portraits of men often include props or background scenes that indicate their professions. Another helpful identifying trait is the red ground with which the Borden Limner customarily prepared his canvas.

This portrait of an unidentified lady is unique in the Borden Limner's oeuvre in that it is his only known full-profile portrait. A second special element in this painting is the drapery at the right edge. The Borden Limner included similar draperies in only two other portraits.

The lady is pictured with several gold chains, which are similar to chains shown in other Borden Limner portraits of in the early 1830s. Her balloon sleeves were fashionable at the time, and the limner has accentuated their form for decorative effect. Although the lady has been rendered in profile, the piece of furniture on which she is seated is pictured in the same manner as in many of his other portraits. In addition, the round object placed in the lower left corner—probably a brass decoration for a bolster cushion—is a trait of many Borden Limner portraits.

A compelling connection between the lives of the Borden Limner and John S. Blunt (1798-1835) has been made on the basis of circumstantial evidence. Blunt, born in Portsmouth, New Hampshire, worked as an itinerant painter in New England. His death came while at sea on a voyage from New Orleans to Boston. He is listed in the Portsmouth business directory in 1821 as an ornamental and portrait painter, and he advertised in 1822 as a profile, profile miniature, landscape, and ornamental painter—yet his only signed works include a variety of landscapes, seascapes, and genre scenes. There are no known portraits signed or inscribed by Blunt.

The connection between the two artists is based on visual evidence of script on certain portraits by the Borden Limner and on ornamental work by Blunt; on the red color used by the Borden Limner for the underpainting of his portraits and by Blunt on the ornamental works; and on correlations between information about the life of each.[40] The portrait signed by Blunt that would perhaps solve the mystery remains to be found.

Provenance:
Charles McCabe – Murray Antiques, Chadds Ford, Pennsylvania.

Exhibited:
The University of Michigan Museum of Art, Ann Arbor, Michigan, *The Borden Limner and His Contemporaries,* November 14, 1976 to January 16, 1977.

Reference:
Bishop, Robert C. H. *The Borden Limner and His Contemporaries.* Ann Arbor: The University of Michigan Museum of Art, 1976.

32.

NOAH NORTH
Dewit Clinton Fargo
1833, New York
Oil on panel, 26⅛ by 21 (66.3 by 53.3)
Signed and dated on reverse: *No. 11 by Noah North/Mr.*
 Dewit Clinton Fargo/Who died July 7th, 1833/AE 12 years
 and *July 8, 1833*

Dewit Clinton Fargo (1821-1833)—evidently named for De Witt Clinton, governor of New York from 1817 to 1823—probably was the son of Orange T. and Sally Fargo of Alexander in western New York. This portrait by Noah North was painted posthumously. The inscription that reads *July 8, 1833* is in the same brown paint that North used for the underpaint in Dewit's portrait—an indication that North started the painting on that date, one day after Dewit's death. Also in 1833, North portrayed Dewit's mother, Sally Fargo. Local records show that Dewit's father was both a farmer and the keeper of the Fargo Tavern, located between Alexander and Batavia.[41]

North worked as a portrait painter in areas of New York, Ohio, and Kentucky during the 1830s, but other details of his life remain unknown. Approximately twenty-five portraits are known today, and six of these are signed. *Dewit Clinton Fargo* is the earliest of the signed works.

Apparently it was not uncommon for parents to commission portraits of children who died young. In the same year that he painted the Fargo child, North also was called upon to do a post-mortem portrait of Oliver Ide Vaughan of Darien, New York.[42] Among other artists who painted such portraits was Isaac Sheffield (see catalog entry 33).

This portrait of young Dewit is painted in a crisp, clean style, and North has conveyed the boy's small size by leaving a great amount of empty space on the panel. Dewit sits proudly and is well dressed, but his expression is tinged with sorrow.

Provenance:
 Private collection.

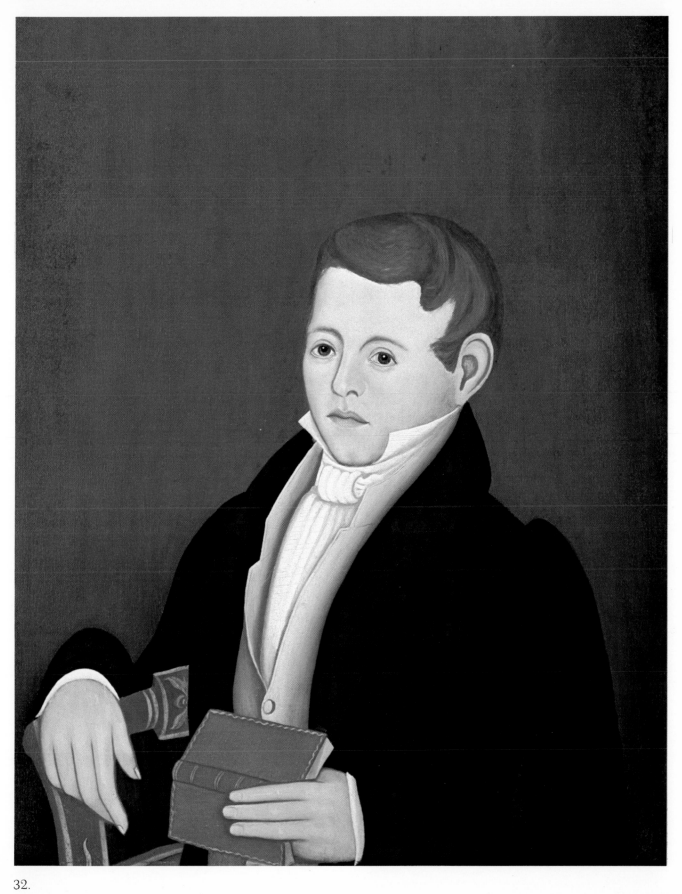

32.

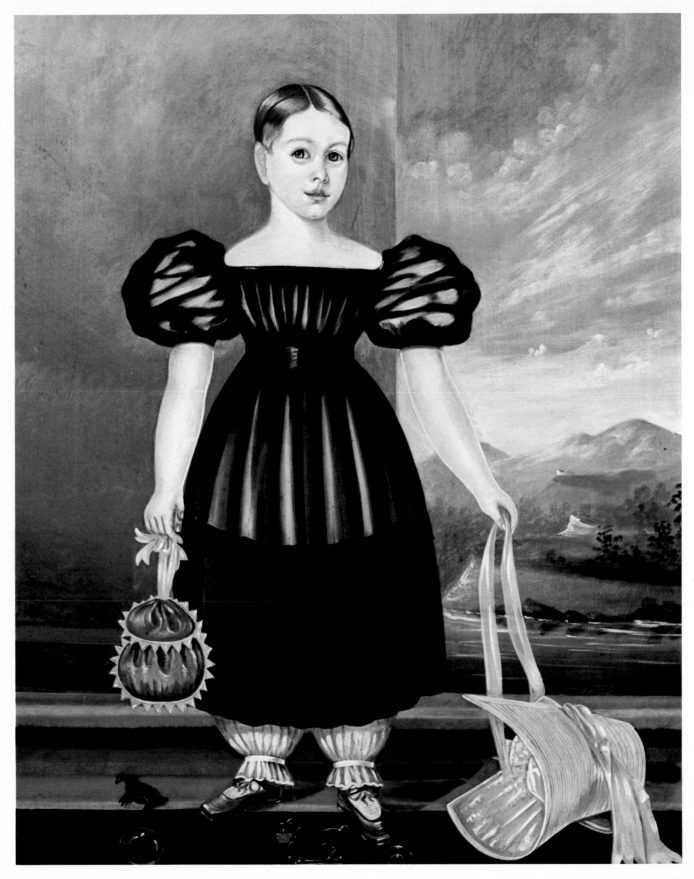

33.

33.

ISAAC SHEFFIELD (died 1845)
Mary Ann Wheeler
1835, Stonington, Connecticut
Oil on panel, 30 by 24 (76.2 by 61)
Signed and dated on reverse: *Isaac Sheffield Pinxt, March 1835*

Mary Ann Wheeler (1833-1835) is identified in an inscription on the back of the painting as the daughter of Homer and Mary Ann Roberts Wheeler of Stonington, Connecticut. She died in January 1835, and her posthumous portrait was completed two months later.[43] In creating this likeness for the child's family, Isaac Sheffield combined free invention with a rather jarring suggestion of realism. His inventive freedom is immediately evident in the age of the girl, whom he has pictured considerably older than her actual two years. The toys scattered at her feet, however, remind us of her actual age. But the ghostly coloration of her skin and the attention devoted to her polydactyl right hand seem to be incongruously realistic details in the otherwise imaginary portrayal.

Details of Isaac Sheffield's life are clouded by conflicting information. He is known to have lived and worked in New London and to have died there in 1845. The year of his birth has not been confirmed. Although dates ranging from 1798 to 1807 have been suggested, 1805 is probably the latest possible date.[44] In a letter, Sheffield named the coastal town of Guilford, Connecticut as his home,[45] and he may have worked as an itinerant painter along the Connecticut coast before setting up shop in the heart of New London's whaling district.[46] At the time, New London was second only to New Bedford in whaling activity, and sea captains formed the greater part of Sheffield's portrait business. The ten paintings by Sheffield that are known today can be divided into three categories: full-length portraits of children (two), half-length portraits of adults (five), and miniatures (three).

Sheffield's portraits of sea captains follow a standard format in terms of pose, the use of a telescope as a prop, the interior setting, and the background seascape with sailing vessel. In a similar manner, the portrait of Mary Ann Wheeler contrasts an interior setting with an atmospheric landscape in the background. By omitting any architectural border unit, such as a window frame, Sheffield created an uncanny spatial ambiguity in the shift from interior to exterior. The child's features, characterized by soft, large eyes, are less distinct than in most Sheffield portraits— probably because he had to work from memory and because he depicted her older than she actually was.

Provenance:
Descended in the Beckwith Jordan family, relatives of Mary Ann Wheeler.
George Considine Antiques, North Dartmouth, Massachusetts.

Reference:
Mayhew, Edgar de N. "Isaac Sheffield, Connecticut Limner." *Antiques* 84 (Nov. 1963): 589-91.

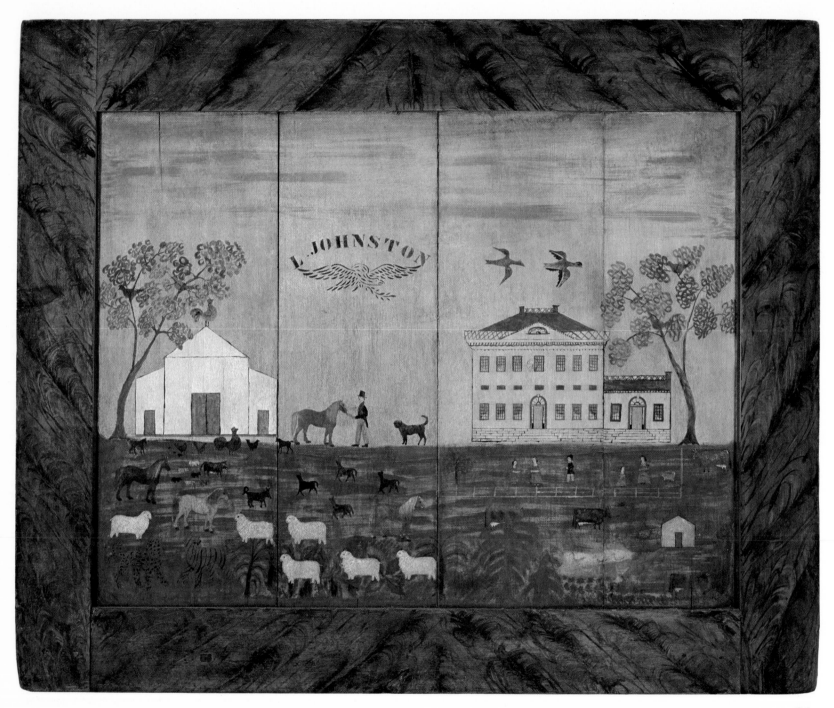

34.

34.

L. JOHNSTON
Farm Scene
ca. 1835, New England
Oil on panel, 44 by 54 (111.8 by 137.2)
Stenciled in sky: *L. Johnston*

This delightful farm scene may have been used as a shop sign for L. Johnston or as a fire board to close off a fireplace that was not in use. The four panels on which the scene is painted are set into grooves in the frame, which was painted to simulate wood grain. Signs of wear in the lower corners of the frame indicate that it may have been inserted into some type of holder. Also, in the top of the frame are holes for leather thongs, which may have been used for additional support or to hang the panel when not in a holder.

Sign and ornamental painters often marked their work by means of stenciled names and emblems placed inconspicuously on the objects they decorated. In this painting, the prominent positioning of the stenciled emblem and name is unusual and suggests personal use of the panel by the artist.

Johnston's untutored style is schematic and relies almost exclusively on profile. Of all the animals, only the exotic leopard and tiger in the lower left corner are painted with a sense of animation. The house is depicted with careful detail, including curtains in the windows, and the farmyard is filled with amusing sights, such as the rooster crowing atop the barn and the cow with her young. Johnston's primitive talent is most conspicuous in the way he placed the animals, one above the other, against the steeply rising ground plane, and in the inconsistency in their sizes.

Provenance:
Mary Allis, Southport, Connecticut.

35.

ROBERT DARLING
Child in a Yellow Painted Chair
ca. 1835, New England
Oil on canvas, 27⅞ by 24 (70.8 by 61)

This portrait of a young child is by the same painter of a portrait in the collection of the New York State Historical Society in Cooperstown, New York. The latter work is also a frontal view of a child, who is seated in what looks to be the same yellow chair, and it is signed by Robert Darling and dated March 14, 1835. No other works by this artist are known.

Darling's style is direct. The child and chair compose a single unit that is set off against a plain reddish-brown background. However, by rounding the forms of the child's dress Darling minimized the sense of rigidity that is often associated with a frontal pose.

Provenance:
R. L. Mills, Exeter, New Hampshire.

36.

ARTIST UNIDENTIFIED
Child in a Green Dress
ca. 1835, Vermont
Oil on canvas, 38 by 25 (86.5 by 63.5)

Despite a lack of technical sophistication, the painter of this full-length portrait attempted to render the young child with a natural appearance and pose, and he compensated for his awkwardness with a gentle and subtle touch. Shoulders and arms evidently presented difficulty to the painter, but in the softly shaded face he managed to capture a childlike appearance—a talent that eluded certain other folk painters. Also, the artist added subtle animation to the painting by picturing the child with a slight turn of the head and forward placement of one foot. Further traces of naturalism appear in the hint of a light source, evident in the shadows around the feet, and in the attempt to create a sense of depth through the convergence and diminution in size of the carpet pattern.

Provenance:
George E. Schoellkopf Gallery, New York.

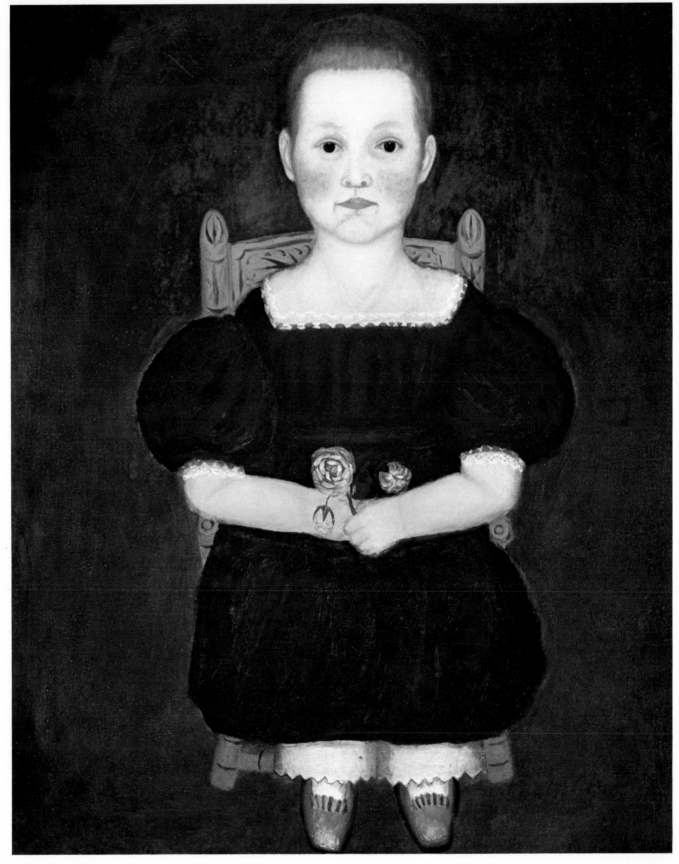

35.

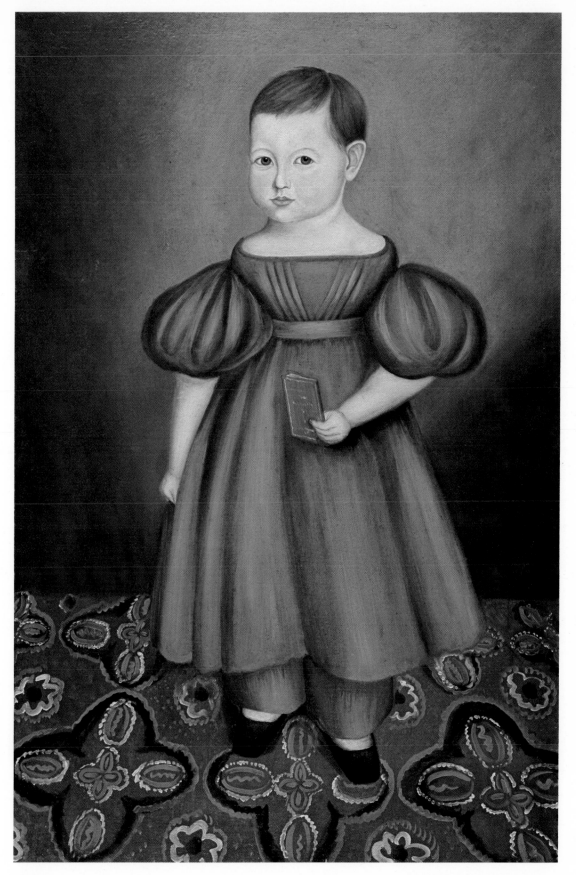

36.

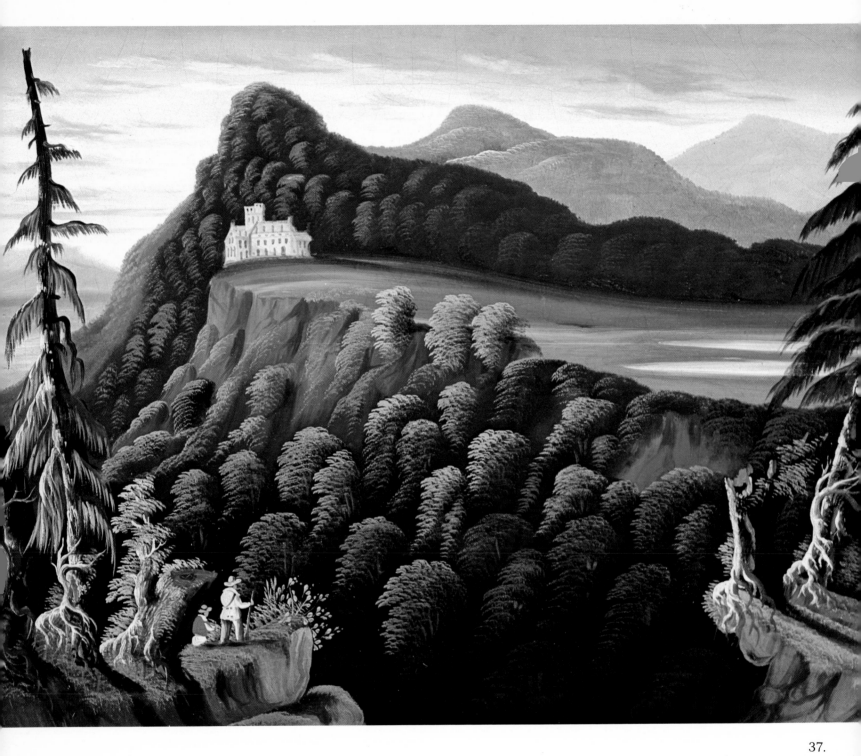

37.

37.

THOMAS CHAMBERS (1808 or 1815–after 1865)
Two Hunters in a Hudson River Landscape
ca. 1840, New York
Oil on canvas, 18¼ by 24⅛ (46.4 by 61.3)

Thomas Chambers was born in England either in 1808 or 1815. He emigrated to the United States in 1832 and was naturalized as a citizen. Chambers was active as a landscape and marine painter from about 1834 until at least 1866, after which there is no further report of him. He lived in the northeastern states, and is recorded as having lived in New York City from 1834 until 1840, in Boston from 1843 until 1851, in Albany from 1852 until 1857, and again in New York from 1858 to 1859 and 1861 to 1866.[47]

Like many American landscape painters, Chambers was attracted to the scenic beauty of the Hudson River Valley. Occasionally he dispensed with originality and based his works on paintings by other artists and on contemporary engravings, which he personalized by the use of bold colors and brushwork. *Two Hunters in a Hudson River Landscape,* with the famous Catskill Mountain House perched high in the background, is related to Thomas Cole's *Catskill Mountain House,* painted in 1825. Both pictures show two hunters in the left foreground and both depict the building from nearly the same angle. Also following Cole's example, Chambers framed the scene with tall trees on either side of the canvas. The Catskill Mountain House was popular both as a resort and a subject for painters, and it also appears in works by Jasper Francis Cropsey and by an unidentified painter after an engraving made by William Henry Bartlett.

Provenance:
> M. Knoedler & Co., New York.
> Hirschl and Adler Gallery, New York.
> Dana Tillou, Buffalo, New York.

Exhibited:
> R. W. Norton Art Gallery, Shreveport, Louisiana. *The Hudson River School: American Landscape Paintings from 1821 to 1907,* October 14 to November 25, 1973.
> Hirschl and Adler Gallery, New York. *Plain & Fancy: A Survey of American Folk Art,* April 30 to May 23, 1970.

References:
> R. W. Norton Art Gallery. *The Hudson River School: American Landscape Paintings from 1821 to 1907.* Shreveport, Louisiana: R. W. Norton Art Gallery, 1973.
> Howat, John K. *The Hudson River and Its Painters.* New York: Viking Press, Inc., 1972.
> Hirschl and Adler Gallery. *Plain &Fancy: A Survey of American Folk Art.* New York: Hirschl and Adler Gallery, 1970.

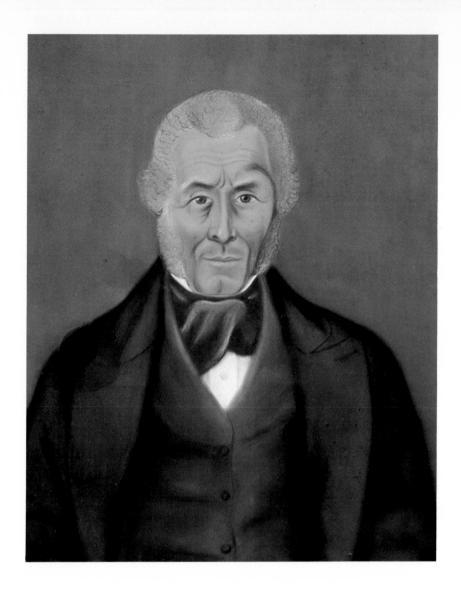

38.

ARTIST UNIDENTIFIED
Sully Watson
Second quarter of the 19th century, Ohio
Pastel on paper, 24 by 19¼ (61 by 48.9)

Sully Watson and his wife (catalog entry 39) were prominent members of the small black community in young Milwaukee. The federal census of 1850 lists Watson as seventy years old and as having been born in Virginia. He and his wife are both listed again in the census of 1860, but only Mrs. Watson's name appears in the 1870 census. Watson's name also fails to appear in the city directory of 1863, indicating that he died in the early 1860s when in his eighties.[48]

The census of 1850 also lists three Watson children between the ages of twenty-two and twenty-three, two born in Virginia and one in Ohio. Thus, the Watsons apparently left Virginia for Ohio sometime in 1828. They evidently did

not move to Milwaukee until just prior to 1850, for they are not mentioned in the 1847 Milwaukee territorial census.[49]

Judging from Watson's age in the portrait, it was probably made before he moved to Milwaukee. The figure fills the width of the paper, causing Watson's image to appear quite massive. Although the pastels give a softness of form and tone, the frontal positioning is visually striking. The artist had a good ability to create an individualized likeness, strong expression, and well-defined facial features.

Provenance:

Antiques, America (Lawrence E. King), Monroe Center, Illinois.

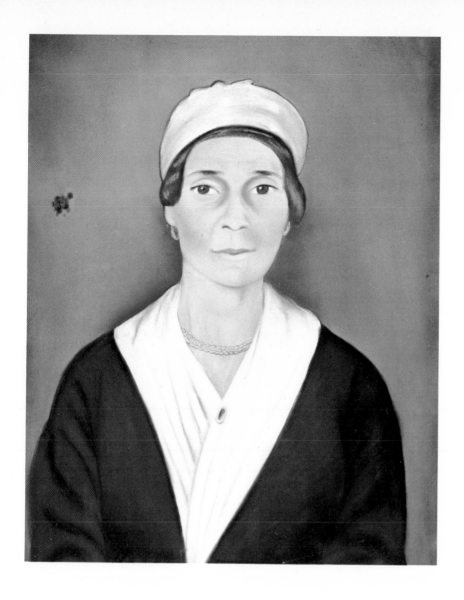

39.

ARTIST UNIDENTIFIED
Susanna Watson
Second quarter of the 19th century, Ohio
Pastel on paper, 24 by 19¼ (61 by 48.9)

Susanna Watson, wife of Sully Watson (catalog entry 38), is listed in the 1850 federal census as fifty-one years old and, like her husband, as having been born in Virginia. Her name appears as late as the 1870 federal census, indicating that she lived at least into her seventies. Like the pastel portrait of her husband, hers apparently also was made in Ohio before the family moved to Milwaukee.[50]

Mrs. Watson is also frontally posed, and although her appearance is noble, her expression betrays a sense of sadness. The heads of both her and her husband are placed at the same height, but her figure is slighter. The softness inherent in pastels has been used to good advantage in rendering the smoothness of her features and her large, soft eyes.

Provenance:
Antiques, America (Lawrence E. King), Monroe Center, Illinois.

40.

SUSAN C. WATERS (1823-1900)
Mary E. Kingman
1845, New York
Oil on canvas, 42 by 28 (106.7 by 71.1)
Signed and dated on reverse: *Mary E. Kingman/Aged 3 Years/1845/Painted by Mrs. Susan C. Waters*

Susan Waters was born in Binghamton, New York, but she grew up in Friendsville, Pennsylvania, where her family had moved when she was still a child. She seems to have had a talent for drawing at an early age, for when she was fifteen she helped pay her tuition at the Female Seminary by doing drawings for the natural history class. In 1840 she was married to William Waters, also of Friendsville, and a few years later she embarked on a brief career as a portrait painter.

From 1843 to 1845 Waters worked as an itinerant artist in the southern tier of New York State, where this portrait of Mary E. Kingman was painted. Her earliest dated portraits were produced during this period in New York, and based on those that survive today, 1845 seems to have been her busiest year. In the late 1840s or early 1850s she and her husband moved to Iowa, but in 1854 they returned east to Bordentown, New Jersey, where they purchased land. A few years later they left Bordentown to travel, and she supported them by teaching painting and drawing, and by making daguerreotypes and ambrotypes. In 1866 they returned to Bordentown, where she remained active as an artist until her death in 1900. She became a noted still-life and animal painter and exhibited her work at the Centennial exposition in Philadelphia.[51]

Waters' portrait of Mary E. Kingman resembles an icon in terms of the young girl's frontal stance and direct outward stare. Careful attention has been given to rendering the fabric of the dress, and the brocade pattern has been translated into paint most delicately. The artist has also used the dynamics of the landscape background to good advantage in projecting young Mary's full-length image. While the distant landscape to the right side breaks the symmetry established by her figure, the forward jump from the trees in the background to those in the foreground visually thrusts her image toward the viewer.

Provenance:
George E. Schoellkopf Gallery, New York.

Exhibited:
George E. Schoellkopf Gallery, New York, *Selected Examples of American Folk Painting, Sculpture, and Pottery,* January 19 to February 2, 1974.

Reference:
George E. Schoellkopf Gallery. *Selected Examples of American Folk Painting, Sculpture, and Pottery.* New York: George E. Schoellkopf Gallery, 1974.

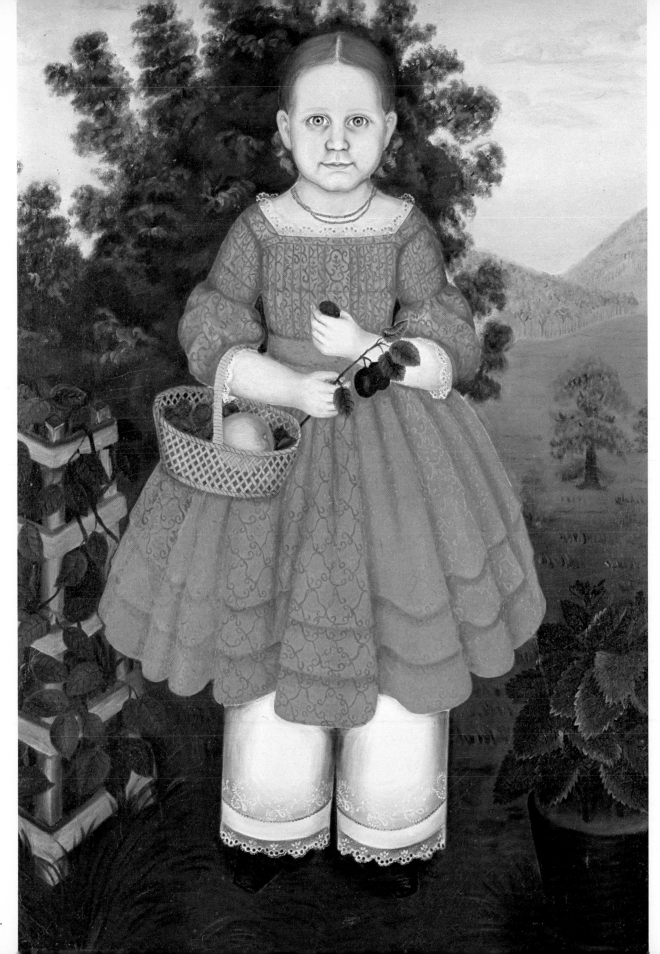

40.

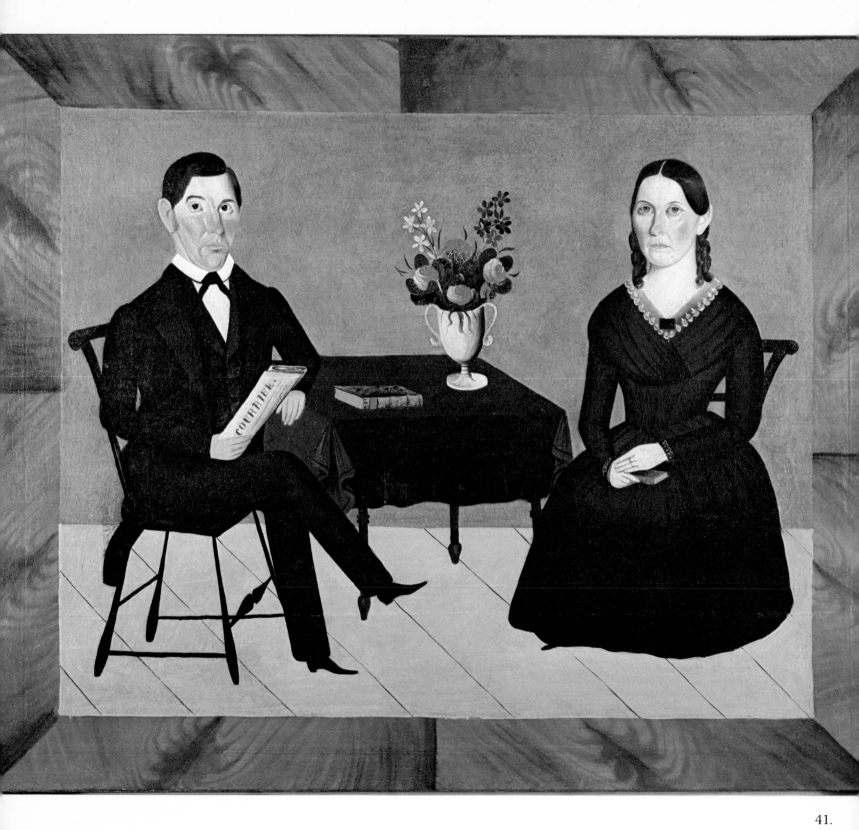

41.

41.

SHELDON PECK (1797-1868)
Mr. and Mrs. David Crane
ca. 1845, Illinois
Oil on canvas, 35¾ by 43¾ (90.8 by 101.1)

During his years in Illinois, Sheldon Peck painted three double portraits of members of the Crane family. David Crane (1806-1849) and Catharine Stolp Crane (1814-1889) lived in Aurora, Illinois where they had settled in 1834 after moving from their home in Poultneyville, New York. Peck, who was a farmer as well as a portraitist, probably painted their portrait on one of his trips to Aurora during the season of the year when farming chores were the lightest.[52] As payment for the portrait, Peck received one cow.

Peck, the ninth of eleven children of Jacob and Elizabeth Peck, was born in the town of Cornwall, Vermont. Family ancestors were among the founders of New Haven Colony in 1635, and his father was one of the first settlers of Cornwall in the years after the Revolution. In 1824, Peck married Harriet Corey of Bridgeport, Vermont, and by 1828 they had settled in the town of Jordan in Onondaga County, New York, near the Erie Canal.

The Pecks moved to Chicago in 1836 and eventually settled in Babcock's Grove, now part of Lombard, a suburb of Chicago. There, Peck became a community leader, and he started the first school and even paid the teacher's salary. It is also reported that his house was used as a stop for slaves escaping by the Underground Railroad. Peck's son Charles, born in 1827, followed his father's artistic inclination and became a landscape painter and photographer; he was also one of the founding members of the Chicago Academy of Design.[53]

As a painter, Peck probably was self-taught, for there is no visible or written evidence that he was trained as an artist. His work falls into three styles that correspond to his years in Vermont, New York, and Illinois. The earliest portraits, from the 1820s, depict, among others, his parents, brother, and sister-in-law. These waist-length portraits are painted on panels and are characterized by dark tones in the sitter's garments and in the background. During his years in New York, Peck painted both half- and three-quarter length portraits on panel, occasionally using a lighter palette and paying closer attention to the details of the setting.

His concentration on domestic surroundings was most intense in his full-length multiple portraits painted in Illinois, and the Crane portrait is a prime example of his work from this period. Painted on canvas, these later works follow a fairly standard format in which the sitters are pictured in simple surroundings, often with a still life of fruits or flowers. The man usually holds a newspaper, and the faces of the sitters are rendered with a stiff severity and with close attention to individual features. In the Illinois portraits, this latter aspect of his style becomes dominant to the point that bodies are painted in standardized poses and in diminished scale. Peck also became adept at reproducing the appearance of wood grain, as in the trompe l'oeil wooden frame that is painted directly on the canvas in the Crane portrait.

Although Peck did not sign his paintings, his work is so distinctive that signatures are not necessary for attribution. Perhaps the most distinguishing feature is the penetrating gaze of his sitters as they stare directly at the viewer.

Provenance:
Descended in the Crane family.

Exhibited:
Whitney Museum of American Art, New York, *Sheldon Peck,* August 8 to October 5, 1975; Abby Aldrich Rockefeller Folk Art Collection, Williamsburg, Virginia, October 12 to December 1, 1975; Munson-Williams-Proctor Institute, Utica, New York, December 14, 1975 to February 8, 1976; Flint Institute of Arts, Flint, Michigan, February 26 to April 4, 1976.

Reference:
Balazs, Marianne E. "Sheldon Peck." *Antiques* 108 (Aug. 1975): 273-84.

42.

JOHN V. CORNELL
"Perry"
1846, New York
Oil on canvas, 25½ by 44½ (64.8 by 113)
Signed and dated lower right: *Drawn & Painted by J. V. Cornell/for Merrss. Bootman & Smith Steamboat Painters/N.Y. 1846*

John V. Cornell, known principally as a landscape painter, was active in the New York City area from 1838 until 1849. His work was exhibited at the National Academy in 1844 and at the American Institute in 1844, 1845, and 1847. A view of the Hudson River Highlands at Newburgh, New York by Cornell is dated 1838, his earliest year of record, and he assisted George Heister in painting a panorama of the Hudson River that was exhibited in New York City in 1849, his last year of record.[54] As indicated by the inscription, the *Perry* was painted for the firm that decorated the steamboat when it was built, and it may have been commissioned for display as an example of their work.

The *Perry* was built in 1845 by Burtis and Morgan of Brooklyn, New York for Rufus B. Kingsly of Newport, Rhode Island. For a number of years the ship ran two round trips daily between Newport and Providence, Rhode Island with an intermediate stop each way in Bristol, Rhode Island. Its timetable was scheduled in conjunction with railroad services for both Providence and Bristol. In 1882 the side-wheeler was rebuilt at Wilmington, Delaware and it was renamed *Delaware*. It burned in Wilmington in 1896.[55]

Cornell's talent as a landscape painter is apparent in the background, which includes a distant shoreline, and sunlit sky and clouds. His eye for visual effects is evident in the figures on the *Perry's* decks who, due to their distance, appear as shadowy silhouettes. (In contrast, James Bard [catalog entry 46] detailed the faces of the men aboard the ships he painted without such consideration of natural effects.) Cornell also portrayed two other paddle-wheel steamers in 1846, the *Narragansett* and the *Roger Williams*, on canvases the same dimensions as this one. It is interesting to note that both are linked to Rhode Island by name.

Provenance:
Kennedy Galleries, Inc., New York.

Exhibited:
Kennedy Galleries, Inc., New York. *American Primitives: Primitive, Folk and Naive Arts from the 18th, 19th, and 20th Centuries,* December, 1970.

Reference:
Kennedy Galleries, Inc. "American Primitives: Primitive, Folk and Naive Arts from the 18th, 19th, and 20th Centuries." *The Kennedy Quarterly,* Vol. X, No. 3 (December 1970).

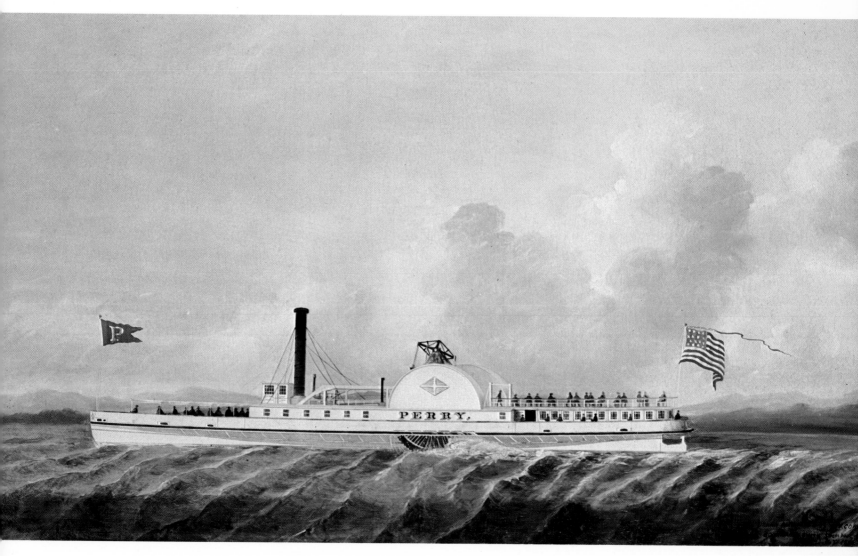

42.

43.

JOSEPH WHITING STOCK (1815-1855)
Double Portrait of a Boy and Girl
1840s, New England
Oil on canvas, 47 by 39 (119.4 by 99.1)

Most of the particulars of Joseph Whiting Stock's life and work are known from his journal, which contains an autobiographical sketch and documents the years 1832 through 1846.[56] Born in Springfield, Massachusetts, Stock was the third of twelve children of John and Mary Stock. At the age of eleven he was involved in an accident with an ox cart, which left him paralyzed from the waist down. So that the bedridden child would be occupied, and thinking that he might make a career as a portrait painter, his physician suggested art lessons. The boy's talent was such that he soon began to develop local patronage for portraits, and eventually, with the aid of a specially designed wheelchair, he was able to travel and to engage new clientele. Stock traveled by train to Massachusetts, Rhode Island, Connecticut, and New York. In 1839, the ill-fated artist was badly burned while making varnish, and ensuing complications forced him to undergo a dangerous operation, but his hardy constitution and strong will pulled him through and enabled him to resume painting. Stock died in Springfield at the age of forty.

There are indications that Stock may have kept other journals, but the known surviving journal lists over 900 paintings—a prodigious amount for any artist, crippled or not. Evidently he worked on the journal sporadically, and he compiled much of it, as well as the autobiographical sketch, in retrospect. The closely clustered dates of the entries in 1843 and the use of the present and imperfect tenses in 1843 and 1846, however, indicate that he wrote actively in the journal, as though keeping a diary, during those years. The final entry dates from August 4, 1846.

A painter of great talent, Stock portrayed individuals of all ages, and while some of his subjects are shown against plain backgrounds, most are pictured in pleasant outdoor settings or in comfortable domestic surroundings. He portrayed children with sensitivity and tenderness, and he often depicted them with pets or with toys, such as a doll, a hobbyhorse, or the baseball that lies on the carpet in *Double Portrait of a Boy and Girl*. The children's sharing of the book and their physical closeness lend a special note of tenderness to this portrait.

Provenance:
Ronald A. DeSilva, Inc., New York.

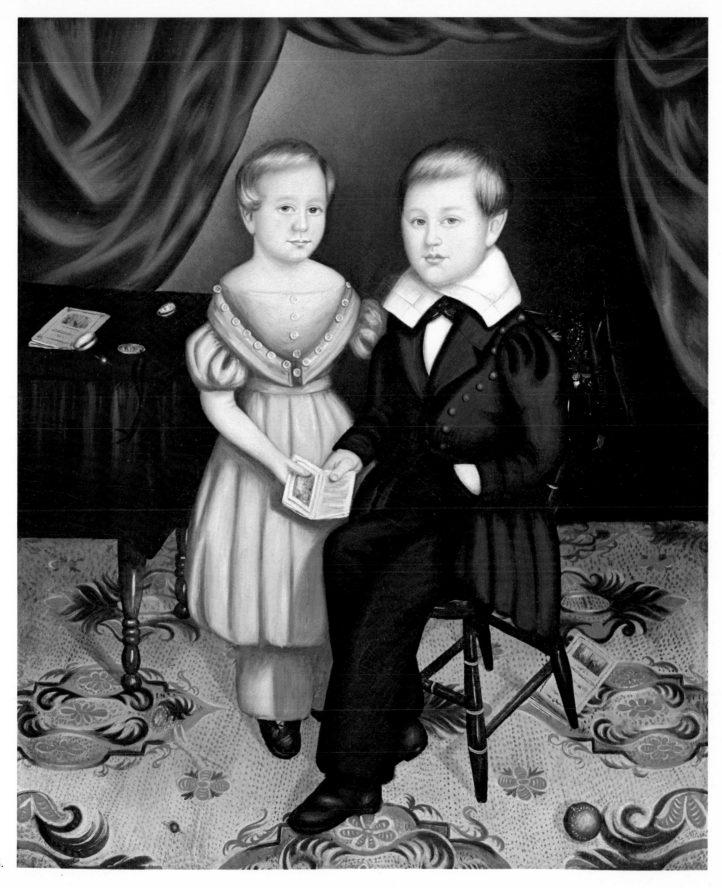

43.

44.

44.

J. A. DAVIS
Triple Portrait
Mid 19th century, Rhode Island
Watercolor and pencil on paper, 11¼ by 14¼ (28.6 by 36.2)

Reconstruction of the career of J. A. Davis has been made possible by the presence of his signature on several portraits, by the names of some of his subjects, and by inscriptions on frames and backboards. But, as the lack of his full name indicates, his biography has been reconstructed only in part. The available clues do inform us that Davis worked in New England, particularly Rhode Island, as well as eastern Connecticut, northeastern Massachusetts, and south-central New Hampshire. However, no evidence has surfaced to connect him conclusively with Joshua Davis, who is listed as a portrait painter in the city directory of Providence, Rhode Island in 1852-53 and 1854-55, and in 1856 as Joshua A. Davis. To date, Davis' oeuvre consists of at least fifty-two signed and attributed works, with 1838 the year of the earliest dated portrait and 1854 the latest.[57]

Davis' few double portraits and this triple portrait, though small, are considerably larger than his single portraits, which often measure no more than five or six inches. Most of his portraits are half-length, with the sitter facing at a slight angle; he also painted a few full-length figures, and one profile is known. His work indicates that he did not have formal training to any extent, but he did develop a distinctive personal style in which he concentrated on rendering an accurate likeness of each sitter. This aspect of his work is evident in the crisp, linear details and in the differences of features from one portrait to another. Davis worked exclusively in watercolor, with the addition of pencil, and was always extremely sparing in the application of paint. This work is special in Davis' oeuvre, for it is his only known triple portrait.

Provenance:
Webster Inc. Fine Art, Maryland.

45.

MARYAN SMITH
The Tow Sisters
1854, Pennsylvania
Watercolor on paper, 14¾ by 12 (37.5 by 30.5)
Signed and dated lower center: *The Tow Sisters. 1854./ MaryAn Smith.*

Eyes attuned to the visual fantasies created by prominent twentieth-century artists are given a treat of color and pattern in this watercolor by MaryAn Smith. The work is characterized by a uniquely conceived palette of equal-value yellow and pink; the contrasting of light and dark values; and the artist's ability to combine outline and pattern in a descriptive manner. Of special distinction is the still-life vase with flowers, carried out in unmodulated tones of red, green, yellow, and black.

MaryAn Smith has united the two girls in form as well as embrace, and, with a refined sensitivity, has set them in harmony with their colorful surroundings.

Although MaryAn is spelled in an unconventional manner, it is difficult to ascertain if in the title "Tow" is a surname or a misspelling of "two."

Provenance:
James and Nancy Glazer, Philadelphia, Pennsylvania.

The Pow Sisters. 1854.

Maryan Smith.

45.

46.

JAMES BARD (1815-1897)
"King Bird"
1855, New York
Oil on canvas, 29½ by 52⅛ (75 by 132.4)
Signed and dated lower right: *Picture Drawn & Painted by James Bard. 1855/162 Perry St. New York/America*

James Bard's long and active career was devoted almost exclusively to recording the steamboats of New York Harbor and the Hudson River area. His principal clients were the owners, builders, and captains of ships who desired portraits of their vessels, and in his obituary he is credited with 4000 such paintings—probably a high estimate. Bard always represented the ships from the side, and the linear precision reflects his careful method of working from scale drawings that he made from measurements or blueprints of the ships. Bard and his twin brother, John, who also painted ship portraits in the New York area, were both self-taught artists. They were born in Chelsea, now part of New York City. James died in White Plains, New York in 1897.[58]

Since most of Bard's artistic efforts were given to representing steam-powered vessels, a schooner such as the *King Bird* is rare in his oeuvre. It also comes from outside Bard's normal working area, for it was built in 1855 by Moses B. Hartt of Northport, Long Island and was used for local freight hauling on Long Island Sound. The *King Bird* was registered in Northport to a Mr. Van Brunt, and it was listed in American Lloyds until 1862, after which time there is no further record. Weighing 237 tons and having a ten-foot draft, it was a relatively large schooner for its type.[59]

In depicting the *King Bird,* Bard paid much greater attention to the hull and sails of the ship than to the accompanying seascape. But in comparison to many of his works, the land, sky, and especially the water, which he often painted in a simplified manner, are depicted with a pleasing naturalism in this painting. Particularly fascinating are the men aboard the vessel, stiff and comical, who in reality could not have been seen with such clarity at so great a distance.

Provenance:
John Lee Pratt, Fredericksburg, Virginia.

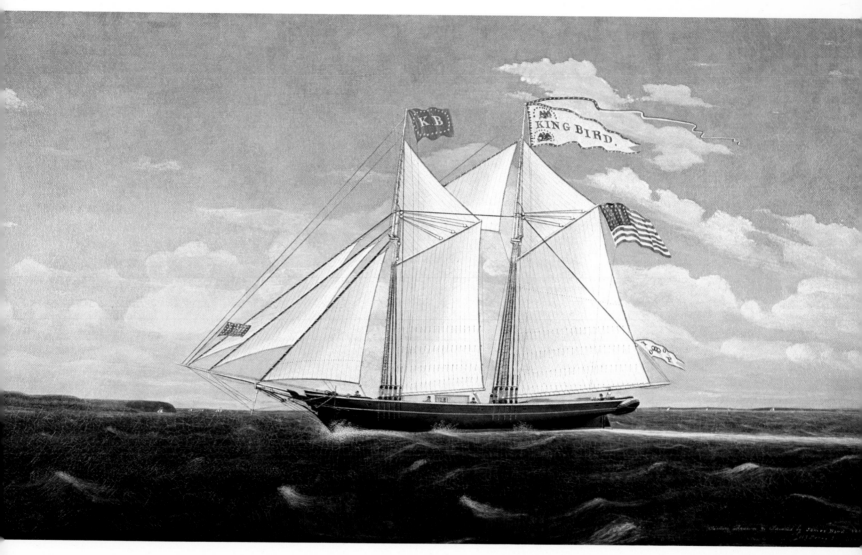

46.

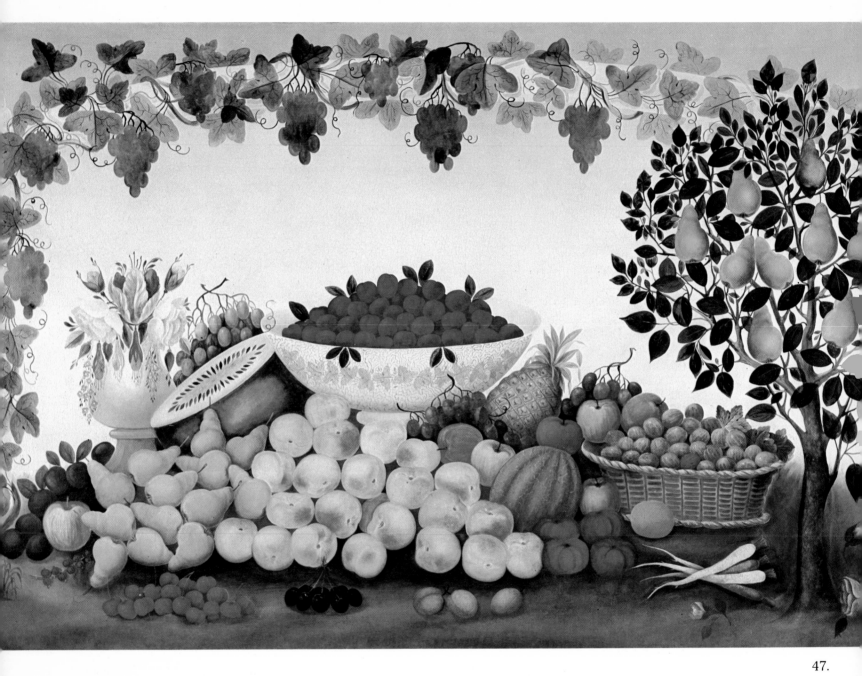

47.

47.

ISAAC W. NUTTMAN
Still Life
ca. 1865, Newark, New Jersey
Oil on canvas, 40¼ by 60 (101.6 by 152.4)
Signed on reverse: *I. W. Nuttman. Painter /8 Coes Place*

Isaac Nuttman's masterful *Still Life* is a consummate expression of abundance and of delight in nature, a delight shared and expressed, though usually to a lesser degree, by many academic and non-academic artists of the United States during the young nation's first century. In contrast to the strict and subdued paintings by many of his contemporaries, Nuttman's exuberant *Still Life* is the product of an unburdened confidence and a fertility of invention that is remarkable in many respects.

In the nineteenth century, the still-life genre was popular with many artists. Of academically-trained masters, one need only cite the names Peale and Harnett. In the non-professional realms, still-life design exercises, called theorem paintings, were especially prevalent among works of young school ladies, and still-life elements also appear in the work of Pennsylvania and Virginia-German fraktur artists. But of the still lifes by these and other folk painters, none equal the grandness of the Nuttman masterpiece.

So grand in scale and conception, this painting was the work of an artist with the rather unexceptional vocation of "ornamental painter." Nuttman lived in Newark, New Jersey from 1835 until 1872. In 1827 he married Charlotte Baldwin, and then remarried in 1839 to Rebecca Thompson. The listing of his wife alone in 1873 would seem to point to the artist's death in 1872 or early 1873. The directories list Nuttman as "Fancy, Sign and Ornamental, Fancy and Chair Painter, Japanner and Bronzer, 113 Market Street. All work executed with splendid style not to be surpassed in this city. . . ." He is recorded at 8 Coes Place, Newark, the address inscribed on the large *Still Life,* from 1863 until 1868.[60]

Nuttman's expressive vigor is obvious in the brightness of his colors and in the multitude of fruits and flowers he gathered. His talent as a painter is displayed throughout the painting, but especially in the ripe gold-and-red peaches. The framing element of the grape-laden arbor, suggestive of sign-painting heraldry, acts as a gateway through which the still-life scene is entered. Nuttman's inventiveness is further apparent in his combination of fruits, both plucked and still on the vine, and in his decision to show the large melon cut open, which reveals the heart of the fruit and creates an additional temptation for the palate as well as for the eye.

Provenance:
Hirschl and Adler Gallery, New York.

Exhibited:
The Hunt Institute for Botanical Documentation, Carnegie-Mellon University, Pittsburgh, *American Cornucopia,* April 5 to July 30, 1976.

The Westmoreland County Museum of Art, Greensburg, Pennsylvania, *Art and the Kitchen,* May 22 to June 29, 1975.

Hirschl and Adler Gallery, New York, *Quality: An Experience in Collecting,* November 12 to December 7, 1974.

Hirschl and Adler Gallery, New York, *American Still Lifes of the Nineteenth Century,* December 1 to December 31, 1971.

Hirschl and Adler Gallery, New York, *Plain and Fancy: A Survey of American Folk Art,* April 30 to May 23, 1970.

References:
Brindle, John V. *American Cornucopia.* Pittsburgh: Hunt Institute for Botanical Documentation, Carnegie-Mellon University, 1976.

Hirschl and Adler Gallery. *Quality: An Experience in Collecting.* New York: Hirschl and Adler Gallery, 1974.

Hirschl and Adler Gallery. *American Still Lifes of the Nineteenth Century.* New York: Hirschl and Adler Gallery, 1971.

Gerdts, William H. and Russell Burke. *American Still-Life Painting.* New York: Praeger Publishers, 1971.

Hirschl and Adler Gallery. *Plain and Fancy: A Survey of American Folk Art.* New York: Hirschl and Adler Gallery, 1970.

48.

48.

ARTIST UNIDENTIFIED
The Slater Mill
ca. 1873, Pawtucket, Rhode Island
Oil on canvas, 20 by 27 (50.8 by 68.6)

The Slater mills in Pawtucket, Rhode Island and their founder, Samuel Slater (born 1768), played significant roles in the introduction of industrial textile manufacturing to the United States. After the Revolutionary War, the United States remained dependent on Great Britain for textiles. There, the industry far exceeded that of the States, both in size and technology. Anxious to develop the obvious American market, Slater left his home in the county of Derbyshire, England in 1789. He arrived in New York, but quickly moved to Pawtucket, where he entered into a partnership with Moses Brown in the company of Almy and Brown. To this firm, Slater contributed his management skills as well as his knowledge of advanced technology.[61]

Pawtucket was an active industrial center, and the falls on the Blackstone River provided an excellent source of energy for the mill operations. By the end of 1792, William Almy and Smith Brown (Moses Brown's nephew) agreed to join Slater in the construction of a new mill, eventually known as Old Slater Mill, that was to become the first successful cotton mill in the United States. It is this mill, its cupola topped by a fish-shaped weather vane, that is pictured in this unattributed canvas. Still wishing to pursue his own management and production ideas, Slater constructed a new mill on the opposite bank of the Blackstone River in 1797. This later mill, which does not appear in the painting, became known as the White Mill.

The painter of *The Slater Mill* worked in a style that is both naturalistic and subdued. He was skilled in depicting natural effects, as can be seen in the play of sunlight across the treetops and the atmospheric perspective of the sky. Whereas other depictions of the Blackstone at Pawtucket show the flow to be torrential, the river appears relatively quiet in this painting. One of the most remarkable passages in the painting is the area in shadow just above the falls.

Provenance:
Mary Allis, Southport, Connecticut.

49.

HENRY DOUSA
The Farm of H. Windle
1875, Indiana
Oil on canvas, 34 by 48¼ (86.4 by 122.6)
Signed and dated lower right: *H. Dousa/1875*

Information about the Indiana painter Henry Dousa is sparse. He may have been born about 1820 in Lafayette, Indiana, where he resided in later years, or he may have come to Indiana from New York. From 1879 until approximately 1885 he worked in New Castle, Indiana; he then returned to Lafayette, where he died in poverty. Before moving to New Castle, Dousa married Lena Icenoggle, who was many years his junior.[62]

Dousa began his career as a painter of farm scenes and prize-winning livestock, and then he turned to portraiture. Five of his portraits, all of them picturing the sitters in frontal poses, hang in the local museum in New Castle. Dousa's paintings of prize livestock follow a common format in which the animals are shown in profile against the green background of the pasture. His views of farms, however, are more complex in composition and draughtsmanship, and are almost exclusively painted in watercolor on paper.

The Farm of H. Windle, one of Dousa's most important works, is his only known farm scene in oil on canvas. This large painting illustrates both his rigid, schematic style and his attention to detail, an aspect that is clearly evident in the picket fence surrounding the farm house. By means of perspective recession and cast shadows, Dousa has attempted, however naively, to achieve realistic effects of space and sunlight. A suggestion of his work as a livestock portraitist is found in the depiction of William Allen, evidently H. Windle's prize bull. Large in proportion to the other elements of the painting, the animal is identified with the inscription: "William Allen/Property of H. Windle/age Five Years/Weight 2500." This inscription probably was not made by Dousa because it is on top of the coat of varnish that was applied to the painting, whereas the signature, "H. Dousa/1875," is under the varnish and differs in lettering style, The inscription naming the bull is the clue to the farm's ownership, but nothing more is known about either H. Windle or his farmstead.

Provenance:
George E. Schoellkopf Gallery, New York.

Exhibited:
George E. Schoellkopf Gallery, New York, *Selected Examples of American Folk Painting, Sculpture, and Pottery,* January 19 to February 2, 1974.

Reference:
George E. Schoellkopf Gallery. *Selected Examples of American Folk Painting, Sculpture, and Pottery.* New York: George E. Schoellkopf Gallery, 1974.

49.

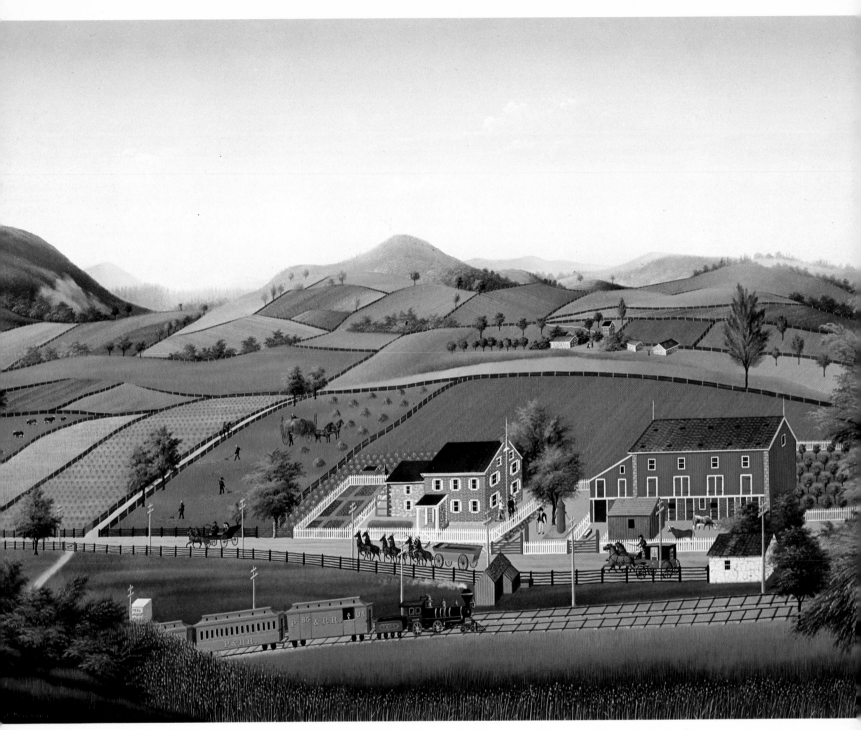

50.

50.

JOHN RASMUSSEN
Berks County Farm Scene
ca. 1880, Berks County, Pennsylvania
Oil on tin, 27 by 36 (68.6 by 91.4)
Signed lower left: *J. Rasmussen*

The beautiful farm country of southeastern Pennsylvania is splendidly represented in this landscape by John Rasmussen. Rasmussen was listed as a painter in the directory of Reading, Pennsylvania from 1867 until 1879, when, due to his "intemperance," he was committed to the Berks County Almshouse. The almshouse register indicates that he was a native of Germany and that he died at the almshouse in 1895. Rasmussen and two other artists, Charles G. Hofmann and Louis Mader, painted scenes of the almshouse and the surrounding area, and collectively they are known as the Pennsylvania Almshouse Painters.[63] Rasmussen painted the almshouse many times, but this is the only known landscape of the surrounding countryside.

Striking colors and sharp details give this farm scene a freshness and an immediate visual appeal that is prolonged by the many activities depicted in the painting. The smooth, hard surface of the tin, Rasmussen's customary support, enabled him to paint the details of the farm and the activities along the roadside with great precision. In addition to his interest in detail, Rasmussen also sought to capture the scenic effects of atmospheric perspective, as illustrated by the subtle transformation of the rolling hills into progressively lighter tones. Rasmussen portrays nineteenth-century country life as both pleasant and filled with activity, and conveys a sense of pride and bounty in the neat fields, the orchard, and the well-kept farm buildings.

Provenance:
R. E. Crawford Antiques, Richmond, Virginia.

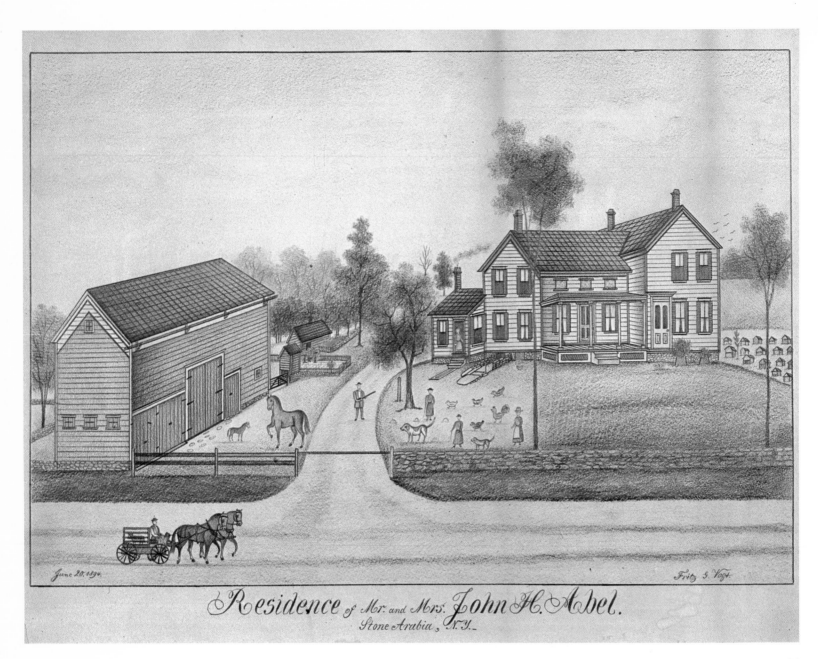

June 20, 1894. Fritz G. Vogt.

Residence of Mr. and Mrs. John H. Abel.
Stone Arabia, N.Y.

51.

51.

FRITZ G. VOGT
Residence of Mr. and Mrs. John H. Abel, Stone Arabia, N. Y.
1894, New York
Crayon and pencil on paper, 17½ by 23¾ (44.5 by 60.3)
Signed lower right and dated lower left: *Fritz G. Vogt* and
June 20, 1894.

The work of Fritz Vogt is distinct in terms of style, medium, and subject matter. Vogt's specialty was portraying houses, which he usually drew on paper with pencil and colored in with crayon. Despite the technical precision of Vogt's drawing of architecture, which must have been accomplished with the aid of a straightedge, he lacked complete understanding of linear perspective. As a result, his houses often appear distorted. Vogt frequently presented only the houses and the street, omitting human or animal presence. Thus, the animals gathered in the yard and the family, who stand as if posing for the artist, give this drawing of the John Abel house a special place among Vogt's pictures. Of Vogt's career, little more is known than that he worked in the area of Albany, New York from about 1890 to 1900.

Provenance:
 H. W. Hemphill.

Exhibited:
 Clover Hall, Shingiku-Isetan, Tokyo, Japan, *American Folk Art from H. W. Hemphill Collection,* March 5 to March 15, 1976; Hankyu, Osaka, Japan, April 2 to April 7, 1976.

Reference:
 Asahi Newspapers. *American Folk Art from H. W. Hemphill Collection.* Tokyo, Japan: Asahi Newspapers, 1976.

NOTES

1. Hezekiah Spencer Sheldon, *Documentary History of Suffield in the Colony and Province of the Massachusetts Bay, in New England, 1660-1749* (Springfield, Massachusetts: Clark W. Bryan, Co., 1879), pp. 89-90.
2. The diaries of Ebenezer Gay, Gay Family Papers, Kent Memorial Library, Suffield, Connecticut.
3. Nina Fletcher Little, "Winthrop Chandler," *Art in America*, vol. 35, no. 2 (April 1947), pp. 77-90.
4. Christine Skeeles Schloss to William E. Wiltshire III, May 16, 1977. Letter in the possession of William E. Wiltshire III.
5. Christine Skeeles Schloss, *The Beardsley Limner and Some Contemporaries* (Williamsburg, Virginia: The Colonial Williamsburg Foundation, 1972). This is the most comprehensive study of the Beardsley Limner to date.
6. Klaus Wust, *Virginia Fraktur, Penmanship as Folk Art* (Edinburg, Virginia: Shenandoah History, 1972), p. 3; idem, "Fraktur and the Virginia Germans," *Arts in Virginia*, vol. 15, no. 1 (Fall 1974), p. 2.
7. Although the term *Taufschein* refers specifically to letters of baptism, for simplicity it is also used in this catalog in reference both to letters of birth and baptism (*Geburts und Taufschein*) and birth alone (*Geburtsschein*).
8. Alice Winchester, "Introduction," *The Flowering of American Folk Art 1776-1876*, by Jean Lipman and Alice Winchester (New York: The Viking Press, and The Whitney Museum of American Art, 1974), p. 9.
9. The genealogical information on the Payne family is recorded in John M. Payne, "Descendants of Archer Payne of 'New Market,'" *The Virginia Magazine of History and Biography*, vol. 24, no. 2 (April 1916), p. 221.
10. Ibid.
11. Ibid.
12. Ibid.
13. Nina Fletcher Little, "Doctor Rufus Hathaway, Physician and Painter of Duxbury, Massachusetts, 1770-1822," *Art in America*, vol. 41, no. 3 (Summer 1953), p. 127.
14. Bill of sale, April 29, 1793, in the possession of William E. Wiltshire III.
15. Little, "Doctor Rufus Hathaway," pp. 95-139.
16. Ibid., p. 97.
17. Bill of sale, January 5, 1793, in the possession of Nina Fletcher Little.
18. Nina Fletcher Little, *Paintings by New England Provincial Artists 1775-1800* (Boston: Museum of Fine Arts, 1976), p. 98.
19. Lawrence B. Goodrich, *Ralph Earl, Recorder for an Era* (New York: The State University of New York, 1967), pp. 1-12. This volume is the source of the biographical information on Ralph Earl.
20. Sources of this material on Budington include Nina Fletcher Little, "Little-Known Connecticut Artists, 1790-1810," *Connecticut Historical Society Bulletin*, vol. 22, no. 4 (October 1957), p. 98; Schloss, *The Beardsley Limner*, p. 34; and Little, *Paintings by New England Provincial Artists*, p. 68.
21. Wust, *Virginia Fraktur*, pp. 20-23.
22. Ibid., p. 23.
23. Wust, "Fraktur and the Virginia Germans," p. 2.
24. Ibid., p. 3. The sample of calligraphy on which the attribution to Barbara Becker is based is reproduced in Wust, *Virginia Fraktur*, p. 5.
25. Wilbur D. Peat, *Pioneer Painters of Indiana* (Indianapolis, Indiana: Art Association of Indianapolis, 1954), p. 36.
26. Mary Black and Jean Lipman, *American Folk Painting* (New York: Clarkson N. Potter, Inc., 1966), pp. 51-52.
27. Peat, *Pioneer Painters*, p. 37.
28. "American Naive and Folk Art of The Nineteenth Century," *The Kennedy Quarterly*, vol. 13, no. 1 (January 1974), p. 62.
29. The portrait of Henry Bliss Porter is reproduced in *Public Auction Catalogue* (Hyannis, Massachusetts: Richard A. Bourne Company, Inc., November 23, 1968), p. 29, illus. no. 41.
30. Black and Lipman, *American Folk Painting*, p. 98.
31. George C. Groce and David H. Wallace, *The New-York Historical Society's Dictionary of Artists in America, 1540-1860* (New Haven, Connecticut: Yale University Press, 1967), p. 507.
32. Black and Lipman, *American Folk Painting*, p. 99.
33. Theodore Bolton, "A Technical Note on the Painting of Gilbert Stuart," *Gilbert Stuart, An Illustrated Descriptive List of His Works*, by Lawrence Park et al. (New York: William Edwin Rudge, 1926), p. 83.
34. Barbara C. and Lawrence B. Holdridge, *Ammi Phillips: Portrait Painter 1788-1865* (New York: Clarkson N. Potter, Inc., 1968). This source furnished the biographical information on Ammi Phillips that follows, except where indicated.
35. Barbara C. and Lawrence B. Holdridge, "Ammi Phillips, Limner Extraordinary," *Antiques*, vol. 80, no. 6 (December 1961), pp. 558-563.
36. Illustrated and translated in Frederick S. Weiser, *Fraktur, Pennsylvania German Folk Art* (Ephrata, Pennsylvania: Science Press, 1973), pp. 18-19.
37. Elizabeth R. Mankin, "Zedekiah Belknap," *Antiques*, vol. 100, no. 5 (November 1976), pp. 1056-1070. This article is the source of the biographical information on Zedekiah Belknap.
38. Ibid., pp. 1060-1061.
39. Robert C. H. Bishop, *The Borden Limner and His Contemporaries* (Ann Arbor, Michigan: The University of Michigan, 1975), pp. 3-58.
40. The connection between the Borden Limner and John S. Blunt is discussed in Bishop, *The Borden Limner*, pp. 12-17.
41. Jacquelyn Oak to William E. Wiltshire III, February 17, 1977. Letter in the possession of William E. Wiltshire III.
42. Ibid.
43. Edgar de N. Mayhew, "Isaac Sheffield, Connecticut Limner," *Antiques*, vol. 84, no. 5 (November 1963), p. 589.
44. Ibid.
45. H. W. French, *Art and Artists in Connecticut* (New York: Da Capo Press, 1970), p. 60 (reprint; original by Lee and Shepard, Publishers, Boston, and Charles T. Dillingham, New York, 1879).
46. Mayhew, "Isaac Sheffield," p. 589.
47. *The Hudson River School: American Landscape Paintings From 1821 to 1907* (Shreveport, Louisiana: R. W. Norton Art Gallery, 1973), p. 32.
48. Harry H. Anderson to Elizabeth T. Lyon, October 3, 1975. Letter in the possession of William E. Wiltshire III.
49. Ibid.
50. Ibid.
51. Colleen C. Heslip to Elizabeth T. Lyon, November 3, 1976. This letter is the source of the biographical information on Susan C. Waters. In the possession of William E. Wiltshire III.
52. Marianne E. Balazs, "Sheldon Peck," *Antiques*, vol. 108, no. 2 (August 1975), pp. 280-282.

53. Ibid., pp. 273-284.
54. Groce and Wallace, *Dictionary of Artists in America*, p. 149.
55. John O. Sands provided this information on the *Perry* from the reference file in the Eldredge Collection, The Mariners Museum.
56. Stock's journal is transcribed in Juliette Tomlinson, ed., *The Paintings and Journal of Joseph Whiting Stock* (Middletown, Connecticut: Wesleyan University Press, 1976), pp. 3-59.
57. Gail and Norbert H. Savage and Esther Sparks, *Three New England Watercolor Painters* (Chicago: The Art Institute of Chicago, 1974), pp. 42-55; Gail and Norbert H. Savage, "J. A. Davis," *Antiques,* vol. 104, no. 5 (November 1973), pp. 872-875.
58. Harold S. Sniffen, "James and John Bard . . . Painters of Steamboat Portraits," *Art in America,* vol. 37, no. 2 (April 1949), pp. 51-66; and Alexander Crosby Brown, "Check List of Works of James and John Bard," *Art in America,* vol. 37, no. 2 (April 1949), pp. 67-78.
59. John O. Sands to Elizabeth T. Lyon, October 4, 1976. Letter in the possession of William E. Wiltshire III.
60. Information on Nuttman provided by Hirschl and Adler Galleries, Inc., New York. Statement in the possession of William E. Wiltshire III.
61. Paul E. Rivard, *Samuel Slater, Father of American Manufactures* (Pawtucket, Rhode Island: Slater Mill Historic Site, 1974). This volume is the source of biographical information on Samuel Slater and historical information on the Slater Mills.
62. Peat, *Pioneer Painters of Indiana,* p. 104.
63. [Tom Armstrong], *Pennsylvania Almshouse Painters* (Williamsburg, Virginia: Abby Aldrich Rockefeller Folk Art Collection, 1968).

INDEX OF ARTISTS
(Numbers refer to catalog entries.)